IMAGES
of America

ROCHESTER'S SOUTH WEDGE

Rose O'Keefe

ARCADIA

Published by Arcadia Publishing
Charleston SC, Chicago IL, Portsmouth NH, San Francisco CA

Printed in Great Britain

Library of Congress Catalog Card Number: 2005928068

For all general information contact Arcadia Publishing at:
Telephone 843-853-2070
Fax 843-853-0044
E-mail sales@arcadiapublishing.com
For customer service and orders:
Toll-Free 1-888-313-2665

Visit us on the Internet at http://www.arcadiapublishing.com

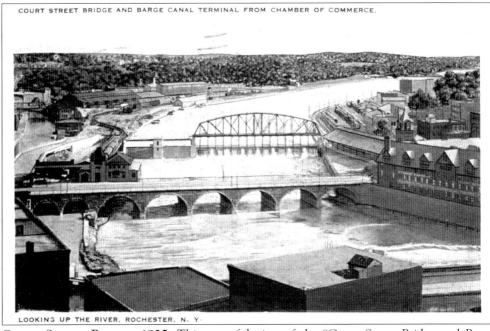

COURT STREET BRIDGE AND BARGE CANAL TERMINAL FROM CHAMBER OF COMMERCE.

LOOKING UP THE RIVER, ROCHESTER, N. Y.

COURT STREET BRIDGE, 1925. This peaceful view of the "Court Street Bridge and Barge Canal" shows the Lehigh Valley Railroad freight station as well as other buildings along Mount Hope Avenue with a backdrop of thick greenery. The postcard was sent in 1925. (Courtesy Josh Canfield.)

CONTENTS

Acknowledgments

The images in this book are used with permission from the following organizations: ABVI-Goodwill Industries, Calvary St. Andrew's Church, Episcopal Senior Life Communities, Landmark Society of Western New York Inc., Rochester City Archives, Rochester City Photo Lab, Rochester Public Library, St. Boniface Church, South Wedge Planning Committee, Schuler-Haas Inc., University of Rochester Rare Books and Special Collections, William Summerhays Inc. Special thanks go to the Rochester City Archives, the Rochester City Photo Lab, the Rochester Public Library, the University of Rochester, Rowe Photographic, and Arcadia Publishing's staff specialists. Thanks go to SWPC board member Dave Halter for having the idea to do this book.

Neighbors who contributed to the book include Rosemary Blanda, David "Josh" Canfield, Bruce Butler for Marie Daley, Christine Dorn, Kathy Englerth, Candy Harris, Helene Honadle, Robert Lauterbach, Robbie and Sam Marble, Robert P. Meadows, Richard O. Reisem, Shirley Smith, George Varga, and Dr. and Mrs. Robert G. Wiltsey.

This book is dedicated to all those who helped make it happen, with special thanks to fourth-generation South Wedge native Josh Canfield, whose generosity rose above and beyond the ordinary.

INTRODUCTION

The traditional hunting and fishing grounds of the Senecas were located between Seneca Lake and the Genesee River. The Senecas had villages, seasonal fishing camps, and sacred burial and ceremonial sites throughout the Genesee Valley. They used the area that now holds the University of Rochester as a fishing camp and avoided the swampy area where downtown Rochester is now located. After the American Revolution, ancient animal and hunting trails were widened into rough roads. The area of today's South Wedge started as a wagon road along the river to the mills and commerce downtown, across the river.

There was only one pioneer family in the primitive Brighton township area of Mount Hope Cemetery in 1810, when places like Phelps and Canandaigua were developing along the old Seneca Trail, now Routes 5 and 20.

Few pioneers came to the woods in the northern tip before the Erie Canal construction had started. The South Avenue district took shape when Irish workers set up camps by their work sites along the Erie Canal in 1819. Most land along the eastern bank was in a remote part of Brighton township until around 1834, so this early history is not often part of general city histories.

Canal construction led to the district's growth as a neighborhood of laborers, shopkeepers, and skilled craftsmen. The district spread from the canal to Sanford Street between 1830 and 1840 with boundaries of downtown on the north, the Pinnacle Hill Range on the south, the canal on the east, and the river on the west.

The South Avenue district had two distinct areas. The Northern Wedge was the smaller triangle north of Sanford Street. Oakland Park spread south of Sanford Street from the Ford Street Bridge, including Mount Hope Cemetery. Highland Park and the land to the east were mainly undeveloped.

From 1820 to 1895, boatbuilding was a major industry in Rochester. The old Stone Warehouse, at the northern tip of the Wedge, is the oldest complete warehouse in the city from that time. Because of the Erie Canal, Rochester was the leading boatbuilding town in the nation.

Mount Hope Cemetery, formed in 1838, is the first municipal Victorian cemetery in the nation. The Ellwanger and Barry Nurseries started with seven acres in the 1840s and had 650 acres by the Civil War. The nurseries were so famous that Rochester was nicknamed the Flower City. Between them, the nurseries and cemetery created a demand for a trolley line along Mount Hope Avenue. It was the first line in the city.

This area was on the Underground Railroad. Frederick Douglass's family lived in Rochester from 1847 to 1872, spending 18 years on South Avenue, which was then on the edge of the city. The industrial expansion at the turn of the century led to a surge in construction throughout

7

the city. The Max Lowenthal building and the old Gregory Street firehouse are reminders of that time.

Several generations of families fell asleep to the rumble and whistles of trains in the Lehigh Valley Railroad yards, which were located along Mount Hope Avenue. The massive changes brought by the railroads and the early subway bed, which was the precursor to Interstate 490, are difficult to see today.

A surprising number of churches have come and gone since those early days. A few 100-year-old businesses remain, including William Summerhays Inc. (which still has the original work sheds built in 1822) and Hunt's Hardware (which began as Lauterbach's Hardware in 1899).

Thank goodness for mapmakers. Without their careful rendering of imaginary lines to separate one ward from another, there would be no measure of the South Wedge's changes. What makes Arcadia Publishing's Images of America series so appealing is the collection of ordinary and one-of-a-kind photographs and postcards that fill in the blanks about an older time. Future generations may look at the 2005 Troop Howell Bridge reconstruction with the same wonderment as Arcadia readers looking at the 1920s subway construction pictures.

Here then is a sampling of people and places. As many photographs as time and space would allow have been included. Each of us plays a part in making a community what it is. Many did so before our time—some famous (such as the Douglass family) and others common (such as the early Miller-Harris family). The Stebbins, Sauer, Gregory, Blanda, Mullen, Schleyer, and Canfield families were all contributors to this community in their day. Despite any shortcomings, ordinary and ambitious people will continue to make the South Wedge a thriving urban village.

One

ALONG MOUNT HOPE AVENUE

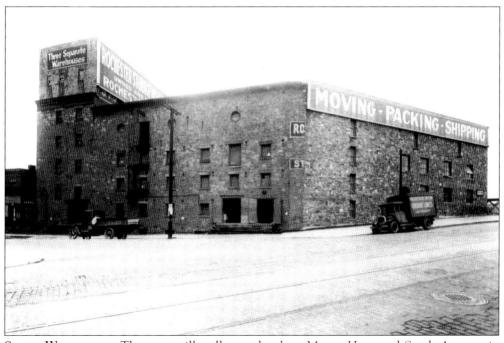

STONE WAREHOUSE. There are still trolley tracks along Mount Hope and South Avenues in this 1930 photograph. (Courtesy Ben Kendig.)

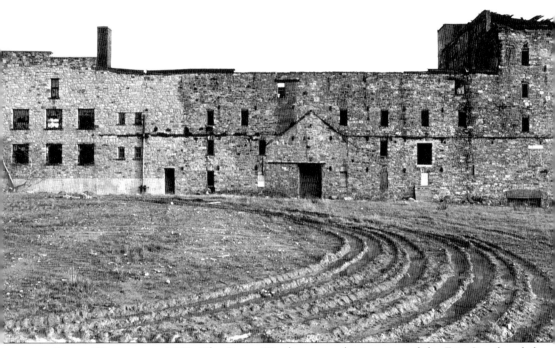

STONE WAREHOUSE, 1982. The Stone Warehouse, at the junction of the Erie Canal and the feeder, was also called Gilbert's Warehouse. It was built by John Gilbert between 1821 and 1822 and was the second warehouse along the canal. The building was made of red sandstone like the Rochester Aqueduct but was abandoned as commerce moved to Child's Basin on the west side of the city. Years passed and the warehouse became a ruin and was reputed to be haunted. In 1838, William H. Cheney rented the skeleton of the building from the owner, Dr. John Elwood, for a furnace and a foundry. Repairs were made, and an engine boiler and other materials were brought by canal from Albany. The first cooking stoves made in this part of the country were manufactured in the building. The foundry's impressive steam engine was a great attraction. The building was a warehouse for eight years and then became empty again. It was used in 1856 for storage and then for tile pottery. A Mr. Oothout bought the building in 1864 and used it to store malt for four years. Samuel Oothout expanded the warehouse to its present size in 1869 for his brewing operations. It was bought by the Bartholomay Brewing Company in 1889. The Stone Warehouse's most productive time was between 1864 and 1905, when Henry Oothout owned the company and ran the country's largest malt house. In 1905, the Rochester Carting Company bought the building and held it until 1968. The interior was heavily damaged after a fire in 1975. Several options for the site were considered without success until developer Ben Kendig bought the building for $1 in 1986 and filled it with offices. It is the oldest complete canal warehouse still standing in Rochester. (Courtesy South Wedge Planning Committee files).

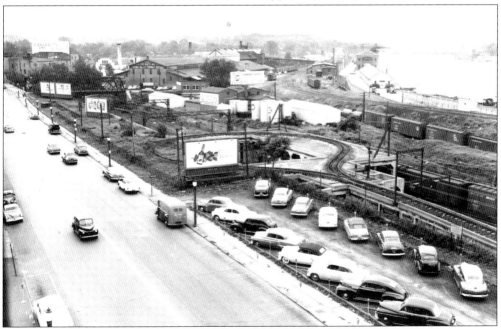

BARGE CANAL TERMINAL, 1930. The Lehigh Valley Railroad freight station is the tall building left of center at the bend of the Genesee River. This postcard is titled "New York State Barge Canal Terminal and South Entrance to New Trolley and Freight Subway System. Looking South on Genesee River, Rochester, NY." (Courtesy Josh Canfield.)

COURT STREET LOOP. Although this September 30, 1953, photograph of the subway turnaround was taken on Mount Hope Avenue, the image is labeled "Court Street Loop." The large building to the left of center is the Lehigh Valley freight station. There is an access bridge over the subway by the Stone Warehouse. (Courtesy New York Museum of Transportation collection.)

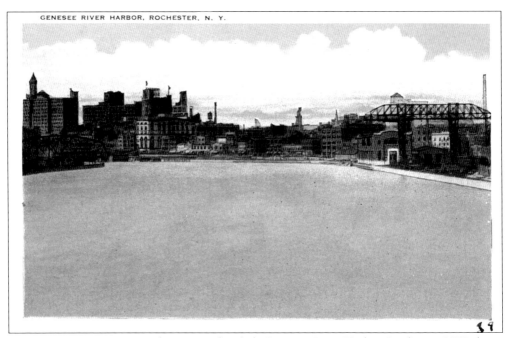

GENESEE RIVER HARBOR, ROCHESTER, N. Y.

GENESEE RIVER HARBOR. This postcard, titled "Genesee River Harbor, Rochester, NY," shows the gantry crane along Mount Hope Avenue. (Courtesy Josh Canfield.)

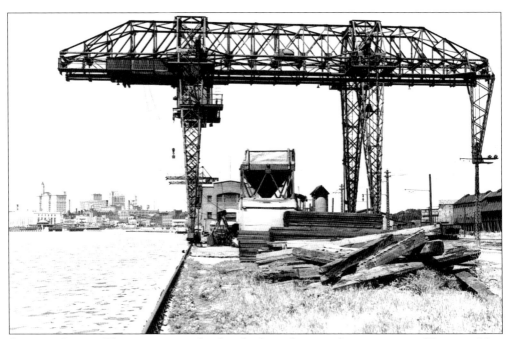

GANTRY CRANE. This crane was a landmark along the river for many years. (Courtesy New York Museum of Transportation collection.)

GUESS WHO. Josh and Tom Canfield and their cousin Sharon Forgue look ready for trick-or-treating as they stand in front of 21 Comfort Street in the 1950s. The large warehouse behind them was along Mount Hope Avenue. (Courtesy Josh Canfield.)

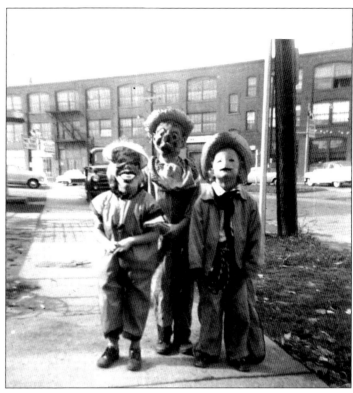

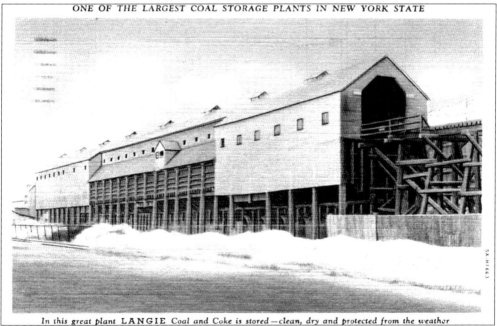

ONE OF THE LARGEST COAL STORAGE PLANTS IN NEW YORK STATE

In this great plant **LANGIE** *Coal and Coke is stored—clean, dry and protected from the weather*

CLEAN AND DRY. This postcard from the 1940s promotes "one of the largest coal storage plants in New York State" in which "Langie Coal and Coke is stored—clean, dry and protected from the weather." Langie also gave a free and useful "Atmostat," which recorded both temperature and humidity, with a trial ton of "Hi-Heat Coal." (Courtesy Josh Canfield.)

THE PROPERTY AT 224 MOUNT HOPE AVENUE, 1964 (ABOVE) AND 2005. The Morrison-Schuler Electric Company was on one side of the building and Archie's Tire Place on the other from 1934 to 1964, with two rented apartments upstairs. Schuler-Haas then took over the building, closed up the storefronts, and converted the apartments into offices. They moved to a larger space at 250 Mount Hope Avenue and donated two buildings as well as the lot to the South Wedge Planning Committee in 2002. The committee sold the house to Savory Thyme Catering in 2003. (Above courtesy Ed Schuler; below author's collection.)

WORLDS APART. While Samuel H. Marble Sr. was stationed in the Philippines during World War II, he had a color portrait of this picture of his young bride, Robbie, painted on silk. It is now a family heirloom.

ANNIE WINMON. Robbie Marble's grandmother Annie Winmon lived with the family from the time they moved in until her death in 1984.

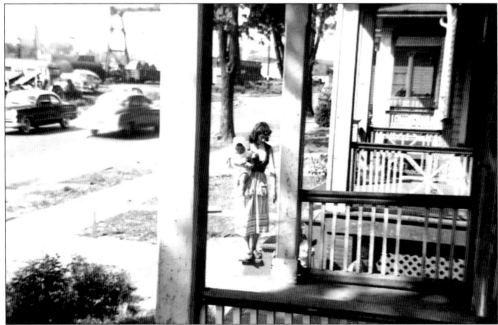

THE OLD FRONT PORCHES. Robbie and Sam Marble were the first black family to buy a house in the neighborhood in 1946. It did not them take long to get used to the sound of trains pulling into the rail yard at 2:00 a.m. Robbie's mother, Mattie Winfrey, lived there for several years, starting in 1948. The old front porches were torn down when the Marbles remodeled.

HEART'S DELIGHT. Annie Winmon holds her great-granddaughter Betty Jean around 1948.

DECISIONS. Little children make big decisions as cars go by on Mount Hope Avenue.

BABY JOYCE. Joyce Marble looks like an urban cowgirl, safe in the driveway.

EDISON TECHNICAL SCHOOL, 1951. In this high school class picture, Robbie Marble's brother Raymond Jordan is fifth from the right in the second row.

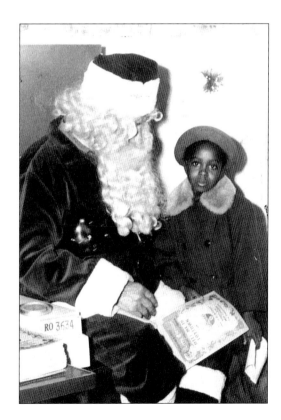

MEETING SANTA. Joyce Marble met Santa downtown at McCurdy's department store for the first time. This photograph was taken around 1952.

NURSERY SCHOOL. Robbie Marble babysat her grandchildren while their parents were at work. Many of them attended Calvary St. Andrew's Nursery School, which opened in 1967. Juanita Marble graduated from nursery school in 1975. (Left and below courtesy Robbie Marble.)

Two

ST. ANDREW'S CHURCH

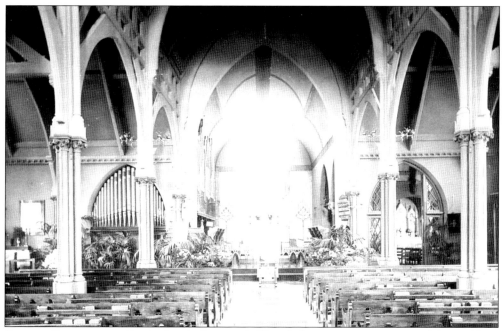

SUNLIT SANCTUARY. St. Andrew's Episcopal Church began as a mission on Mount Hope Avenue in 1865 and was first called St. Clements. Construction of the church on Averill Avenue began in 1871. A temporary church was used on South Avenue near Alexander Street. The chancel, chapel, and part of the rectory were finished in 1874. The sun shines through Tiffany windows over the new marble altar around 1899.

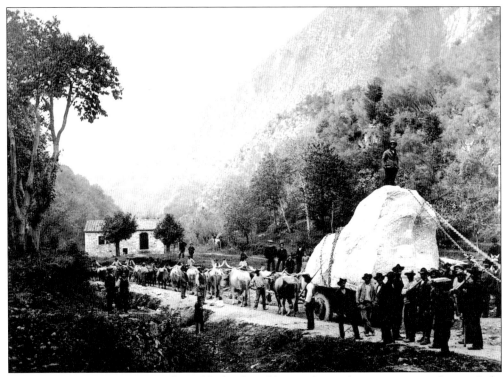

HEADED FOR PARIS. In 1898, a huge block of marble was drawn from a quarry in Coran, Italy, for a new altar at St. Andrew's Church.

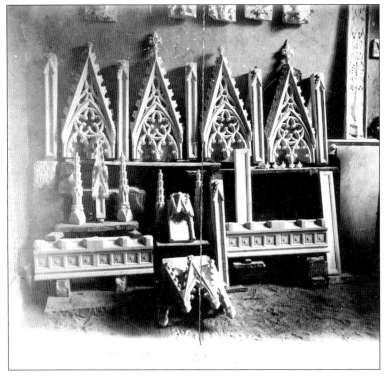

MASTERPIECE IN THE MAKING. The altar was carved in Paris in 1899.

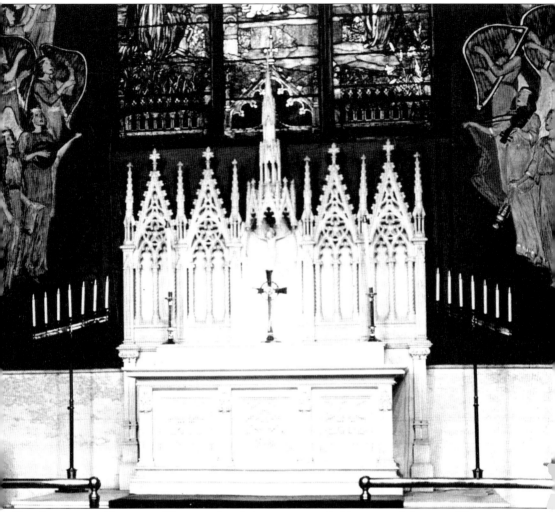

THE ALTAR AND FRESCOES. The completed altar is surrounded by original frescoes. (Courtesy Calvary St. Andrew's Church.)

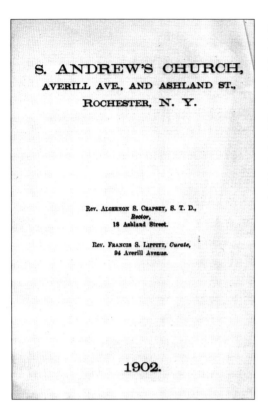

S. ANDREW'S CHURCH,

AVERILL AVE., AND ASHLAND ST.,

ROCHESTER, N. Y.

Rev. ALGERNON S. CRAPSEY, S. T. D.,
Rector,
18 Ashland Street.

Rev. FRANCIS S. LIPPITT, Curate,
94 Averill Avenue.

1902.

ST. ANDREW'S BULLETIN, 1902.
Rev. Algernon Crapsey is listed as rector on the front cover of the St. Andrew's bulletin. He became rector in 1879 and made St. Andrew's the first "free" church in the city where pews were no longer sold. He also established the St. Andrew's Brotherhood, a fraternal organization open to all denominations. In 1906, he was expelled from the Episcopal Diocese for his controversial ideas. (Courtesy Josh Canfield.)

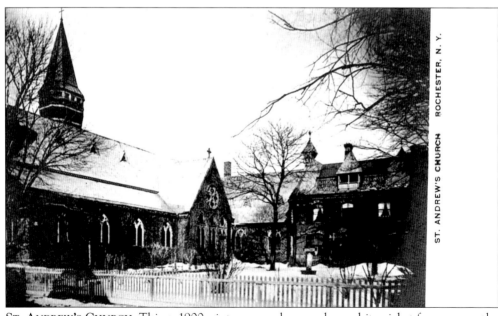

ST. ANDREW'S CHURCH. This *c.* 1900 winter scene shows a clean white picket fence across the churchyard. (Courtesy Josh Canfield.)

INSIDE COVER. Two grocery stores, a tailor, and a meat market were among the advertisers in the 1902 church bulletin. (Courtesy Josh Canfield.)

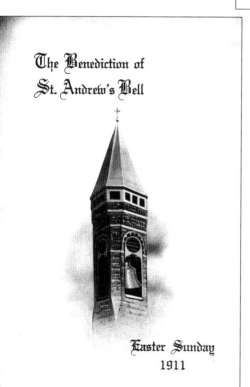

The Benediction of
St. Andrew's Bell

Easter Sunday
1911

BENEDICTION, 1911. The new bell at St. Andrew's was blessed on Easter Sunday. (Courtesy Josh Canfield.)

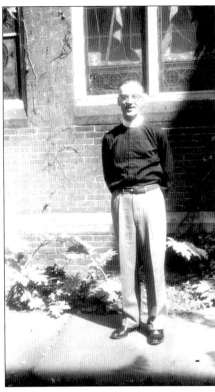

KINDLY PASTOR. Fr. Alton Stivers poses by the church around 1950. (Courtesy Candy Harris.)

REJOICE! Lifelong St. Andrew's parishioner Dan Barley is the third singer on the right in the second row in this 1963 Christmas pageant. Dan made a special appearance at the nursery school supper with Santa for many years. His wife, Dorothy, was director of the nursery school from its beginning in 1966 until 1987. (Courtesy Candy Harris.)

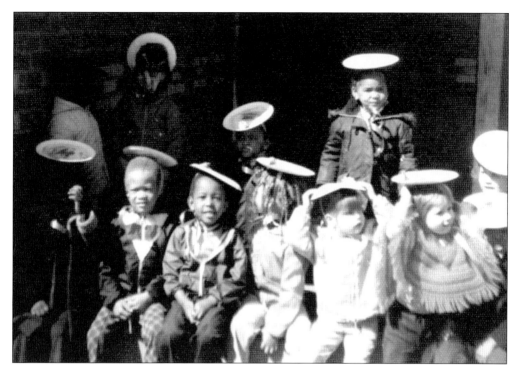

PARTY HATS. Since Rochester weather is notoriously fickle in the springtime, it is hard to tell whether these are Easter bonnets or graduation caps. This group of Calvary St. Andrew's preschoolers is on the back porch by the playground around 1975. (Courtesy Candy Harris.)

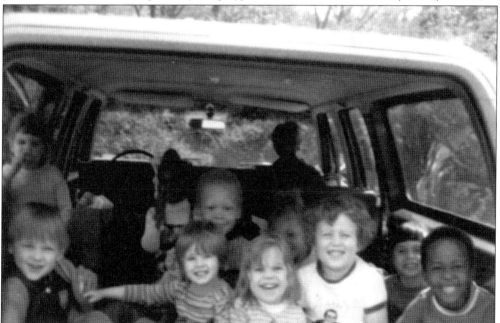

FIELD TRIP. Annual outings to the zoo or pumpkin farm were made easier with the help of Dorothy Barley's Suburban. This photograph was taken around 1975, before car seat laws. (Courtesy Candy Harris.)

GRADUATION DAY. Teacher Kathy Englerth (left) and director Dorothy Barley worked at the nursery school together. They gave generations of neighborhood children their first graduation party. This photograph was taken around 1984. (Courtesy Calvary St. Andrew's Pre-School.)

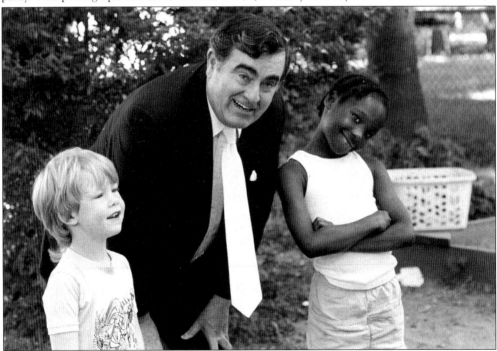

ELECTION YEAR VISIT. Mayor Thomas Ryan enjoyed his first visit to the nursery school in 1988 so much that he returned for a campaign photo shoot with Aaron Soule and this unidentified girl. (Courtesy Kathy Englerth and City Communications.)

Three

By the Bridge

Five O'clock Tea. The Episcopal Church Home for the Elderly, Destitute, and Orphaned Children was begun in a house along the Genesee River, near the Clarissa Street bridge, in 1868. The house was replaced by a larger building in 1869. This photograph is from the late 1800s. (Courtesy Episcopal Senior Life Communities.)

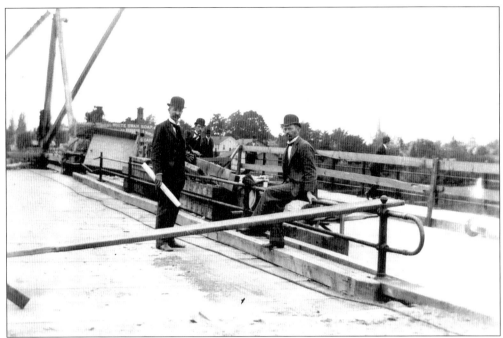

INSPECTION, 1892. These unidentified men are shown on the east end of the Clarissa Street bridge in a photograph dated September 17, 1892. (Courtesy Rochester City Archives and Rochester City Photo Lab.)

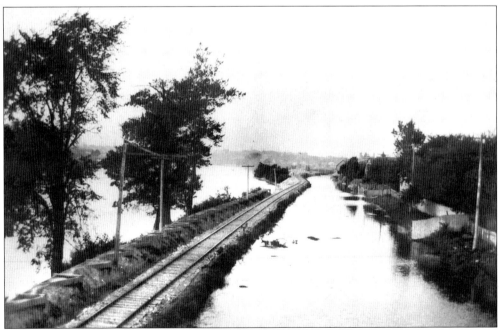

LOOKING NORTH, 1892. This photograph, dated September 18, 1892, shows the view from the Clarissa Street bridge, looking north. The Genesee River is to the left, and the Erie Canal feeder is on the right of the tracks. (Courtesy Rochester City Archives and Rochester City Photo Lab.)

SUMMER IN THE CITY. Mount Hope Avenue from Sanford Street looks as peaceful as can be on July 20, 1892. The Episcopal Church Home would be out of sight on the right. (Courtesy Rochester City Archives and Rochester City Photo Lab.)

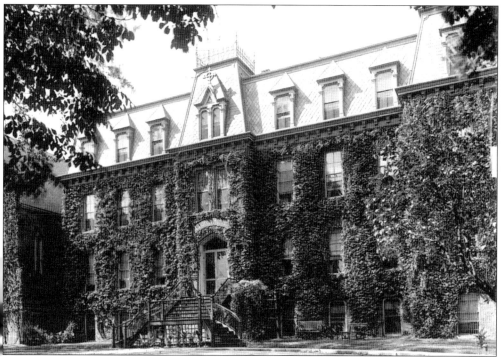

THE OLD CHURCH HOME. Land for the church home was donated in 1869 by George E. Mumford and George R. Clark. The ivy-covered building is shown in 1960.

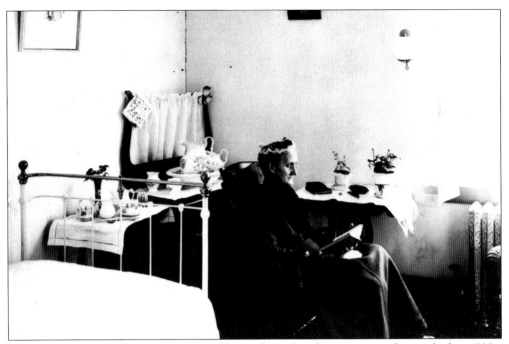

QUIET TIME. A resident enjoys a book and her rocking chair by a sunny window in the late 1890s.

ON PARADE. The children's choir is on parade in this undated photograph.

SPECIAL OCCASION. These girls, lined up in 1921, look ready for something special.

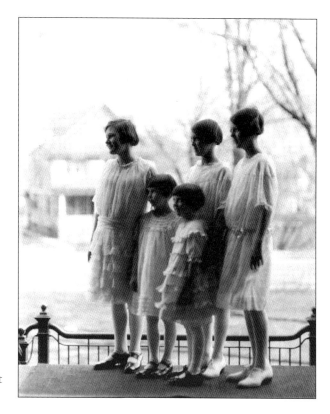

THEIR SUNDAY BEST. Four well-dressed girls pose outside the front doorway in 1924.

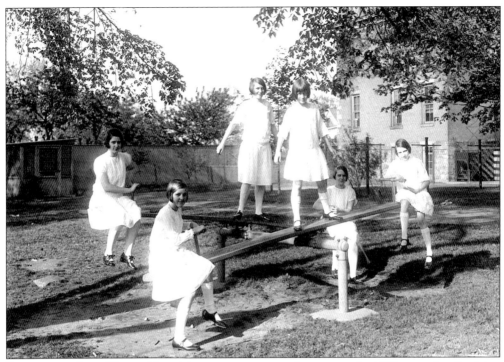

BALANCING ACT. These older girls seem at ease on the seesaws in 1929, even in all white. (Courtesy Episcopal Senior Life Communities.)

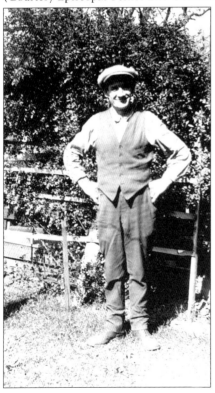

A HAPPY MAN. William Mullen looks happy with his lot in life in the summer of 1926. (Courtesy Shirley Smith.)

HAPPY TOGETHER. In the 1926 city directory, William Mullen was listed as a dairyman with his wife, Bessy, at 4 Sanford Street. They lived in a cottage behind the bigger house at 271 Sanford Street for many years. (Courtesy Shirley Smith.)

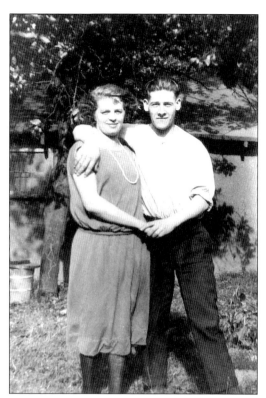

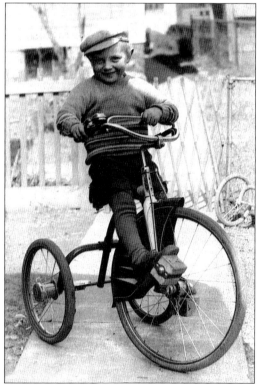

NEW TRICYCLE. Kenneth Mullen, age three, is ready to roll on his new tricycle in the 1930s. He died in the Korean War when he was only 19. (Courtesy Shirley Smith.)

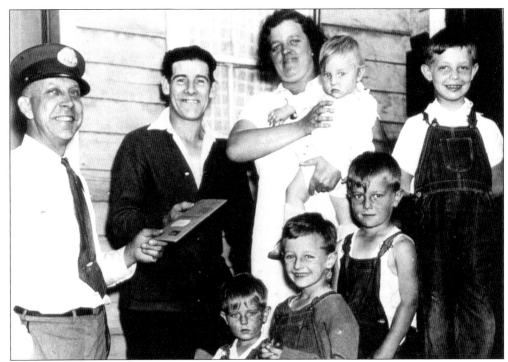

GOOD NEWS. Whatever the contents, William and Bessy received a welcome letter. (Courtesy Shirley Smith.)

WAITING FOR SANTA. Shirley Smith's mother, Lois Mullen, is the baby in the picture, taken around 1938 on Sanford Street. (Courtesy Shirley Smith.)

THE MULLEN KIDS.
Lois and her brothers put the mischief on hold for the camera. (Courtesy Shirley Smith.)

THE NEW HOUSE. After living in a cottage, this house must have felt really roomy. Lois Mullen poses outside 33 Gregory Street. (Courtesy Shirley Smith.)

Everything but the Kitchen Sink. The sink has not shown up yet in the back yard at 33 Gregory Street during remodeling in the 1940s. (Courtesy Shirley Smith.)

Four

SOUTH OF CYPRESS

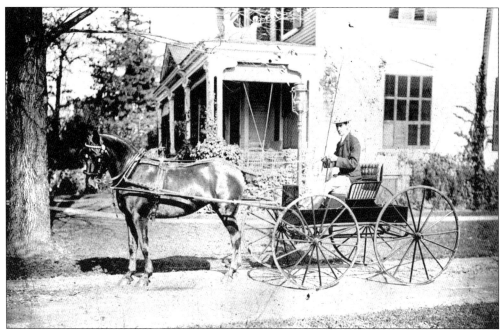

HORSE AND CARRIAGE. Patrick Barry's house, at 692 Mount Hope Street, was designed by English architect Gervase Wheeler and built between 1855 and 1857. In this undated photograph, an unidentified man sits in a carriage by the Barry house. (Courtesy University of Rochester Rare Books and Special Collections.)

NEW SISTER. Marie Eva Daley was seven months old and her brother Sam was two years old when they posed so carefully for the camera in 1904. (Courtesy Bruce Butler.)

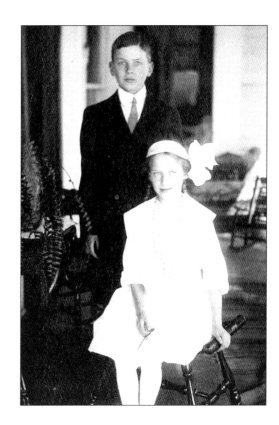

PICTURE PERFECT. This shot of Marie and Sam was made into a postcard. (Courtesy Bruce Butler.)

GRADUATION, 1928. Marie Daley is listed as one of 14 graduates in the commencement exercises for Rochester City Normal School on January 28, 1928. (Courtesy Bruce Butler.)

Graduating Class of January, 1928

GRADE COURSE

Harriet Betz	Arlene V. Fritz
Carolyn Boyd	Doris M. Garnish
Harriet Byer	Helen L. Kress
Marie Daley	Hannah Reeps
Jeanne Marion DiPasquale	Lucille E. Reuschle
Dorothy Dowd	F. Elizabeth Stevens
Thelma Feldman	Beulah M. Wilson

KINDERGARTEN-PRIMARY COURSE

Mary Helen Allen	Ruth Kelley
Ruth S. Geyer	Kathryn J. Reider
Sophia Greffrath	Dorothy VanValkenburg

THE DALEY FAMILY. Marie Daley lived with her family—her grandmother Imogene Johnson; her father, Clarence E. Daley; and her mother, Isadora R. Daley—on Mount Hope Avenue. After her father died, Marie retired as principal of School 13 to take care of her mother. (Courtesy Bruce Butler.)

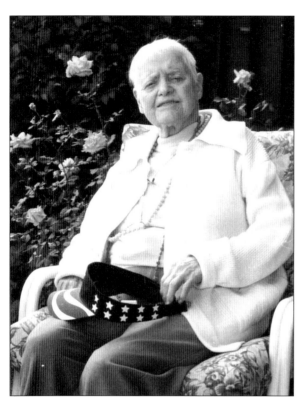

ALMOST 100. Marie Daley enjoys the roses in 2004, months before her 100th birthday party at the Episcopal Church Home, directly across the street from the Mount Hope Avenue home she lived in for many years. (Courtesy Bruce Butler.)

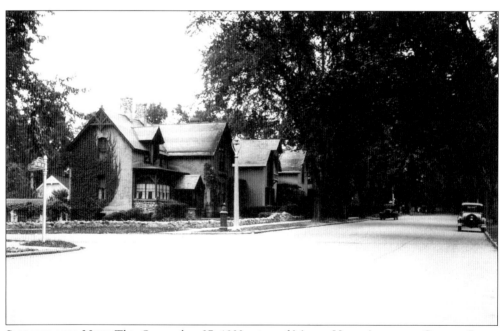

SMOOTH AND NEW. This September 27, 1933, view of Mount Hope Avenue at Cypress Street shows a road that looks wide and smooth. (Courtesy Rochester City Archives and Rochester City Photo Lab.)

THE OLD CARRIAGE HOUSE. The carriage house at 560 Mount Hope Avenue was built at the same time as the house in 1868. It had a stable for one horse, a hay loft reached by a steep stairway on the right, and parking for a horse-drawn carriage on the left. The boy pictured is Duncan Remington, son of the owners. This photograph was taken around 1940, before the carriage house was torn down and replaced by a garage. (Courtesy Richard O. Reisem.)

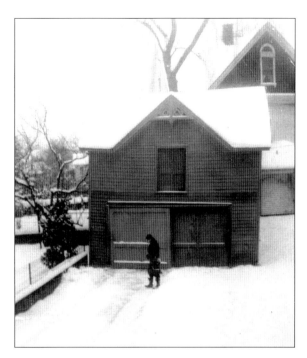

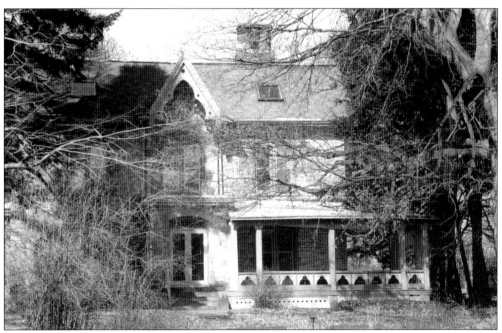

STONE BEAUTY. George Ellwanger Jr.'s house, at 593 Mount Hope Avenue, was listed in city directories as Belvidere Hospital from 1926 until 1942. The Hurlbut Sanitarium, or Hurlbut Private Hospital, was listed there from 1943 until the mid-1970s. Tom Cantin, who bought the property in 1979, said the building was a home for wealthy, unwed mothers at the turn of the century. (Courtesy Robert P. Meadows.)

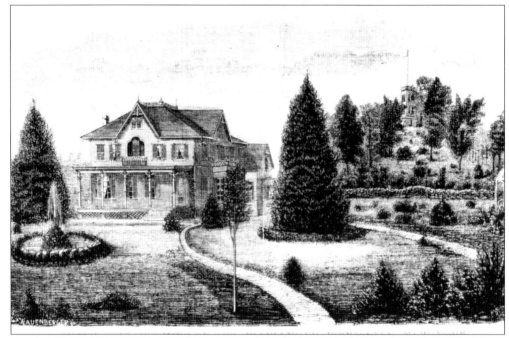

House and Grounds. George Ellwanger purchased a house for his family in 1867. It had been built in 1839 by James Hawks, enlarged by A. J. Warner in 1867, and again in the early 1900s by his son J. Foster Warner. The Ellwangers' street number on Mount Hope Avenue changed from 275 to 625 after 1902. This undated postcard illustration shows an observatory on the property. (Courtesy Rochester City Photo Lab.)

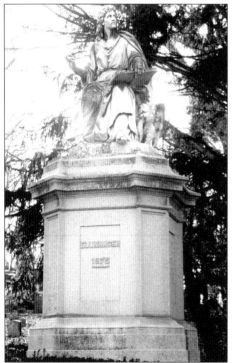

Family Monument. Nurseryman George Ellwanger (1816–1906) was an authority on roses, with a collection of 400 varieties of tea roses. He also introduced dwarf apple and pear trees, apple species including the Northern Spy, and the German tradition of Christmas trees. Ellwanger also raved about the charm of a European azalea produced from the hybridization of the wild honeysuckle and a swamp azalea that grows from Maine to Florida in woods and thickets. He is buried in the family plot at Mount Hope Cemetery. (Courtesy Robert P. Meadows.)

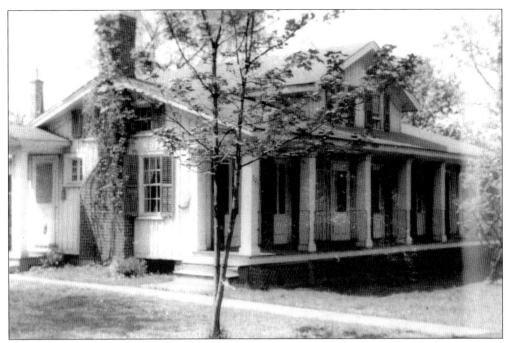

IN SUMMER AND WINTER. The charming house at 701 Mount Hope Avenue at McLean Street was the home of Prof. Glenn and Mrs. Leyla Wiltsey from 1946 to 1998. It was built in the late 1830s. (Courtesy Dr. and Mrs. Robert G. Wiltsey.)

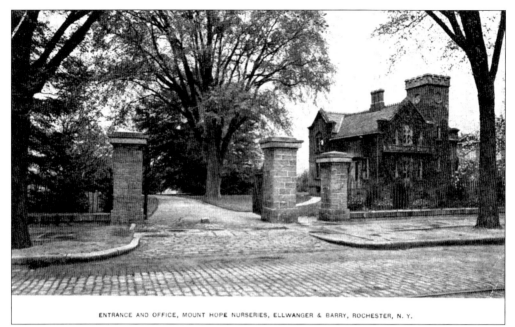

ENTRANCE AND OFFICE, MOUNT HOPE NURSERIES, ELLWANGER & BARRY, ROCHESTER, N. Y.

ENTRANCE AND OFFICE. George Ellwanger came to the United States from Germany in 1835. He worked for Reynolds and Bateham for four years, when he purchased their business and bought eight acres on Mount Hope Avenue. Patrick Barry, a nurseryman who had completed an apprenticeship in Ireland, joined him in 1840. They formed the Mount Hope Botanical and Pomological Gardens. The partners built the office, designed in Gothic Revival style by Alexander J. Davis, in 1854. Thousands of trees were planted on the grounds surrounding the building, including elm, beech, hornbeam, linden, chestnut, purple and fern-leaved beech, ponderosa pine, Nikko fir, American yellowwood, and ginkgo. (Courtesy Josh Canfield.)

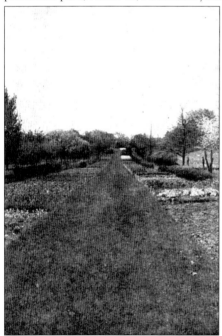

GRASS WALK. Ten-foot-wide flower borders lined a quarter-mile-long grass promenade. There were 16 attached greenhouses in a grid, carpenter shops, packing houses, root cellars, equipment and storage sheds, and horse barns. Ellwanger and Barry invited the reader to return the postcard for a "Complete Illustrated Catalogue" of 104 pages. One card showed the grass walk facing west; this one faces east. (Courtesy Josh Canfield.)

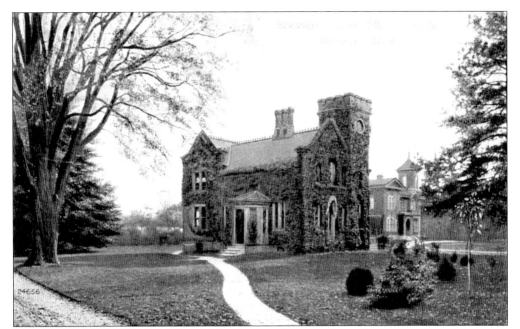

OFFICE GROUNDS. By 1855, Ellwanger and Barry's Mount Hope Nurseries had tripled in size. It became the largest nursery farm in the country and the world. The first orange groves in California and the flowering cherry trees in Japan originated in Ellwanger and Barry's nurseries. They grew over 2,000 varieties of fruit trees. The postcard of the "Ellwanger and Barry Office Grounds" seen from the south was sent in 1915. (Courtesy Josh Canfield.)

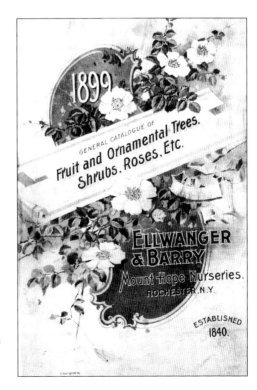

ELLWANGER AND BARRY'S 1899 CATALOG. This is the cover of Ellwanger and Barry's 1899 general catalog for the Mount Hope nurseries. (Courtesy Rochester City Photo Lab.)

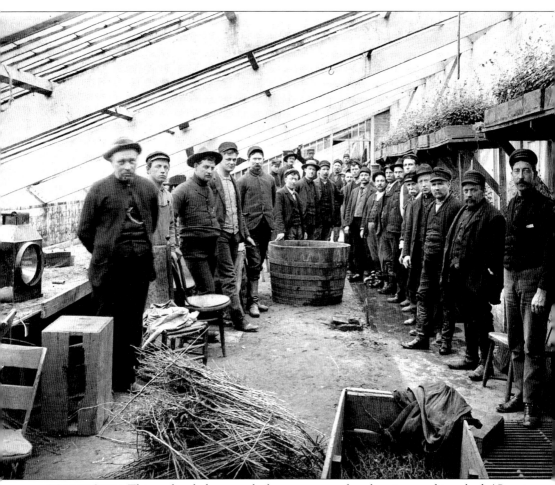

MEN IN SHED. This undated photograph shows a group of workers in a packing shed. (Courtesy University of Rochester Rare Books and Special Collections.)

Five

THE TIP OF
SOUTH AVENUE

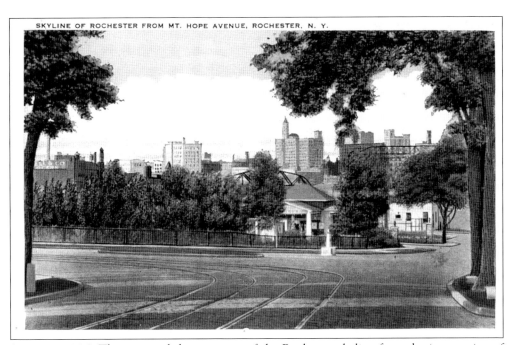

SKYLINE, 1936. This postcard shows a view of the Rochester skyline from the intersection of Mount Hope and South Avenues. (Courtesy Josh Canfield.)

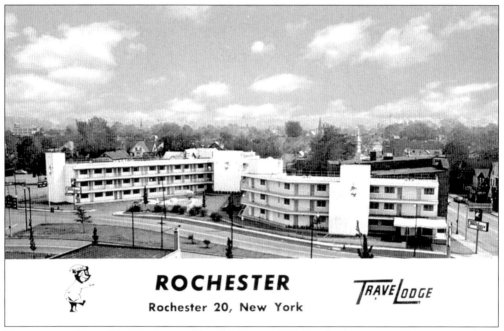

ROCHESTER

Rochester 20, New York

TRAVELODGE

FRESH AND NEW. The Rochester TraveLodge, at 390 South Avenue, is shown at its best. (Courtesy Josh Canfield.)

GREENHOUSE. In the late 1970s, Just Neighbors, a group of community gardening advocates, added a solar greenhouse to 425 South Avenue. It has since been enclosed. (Courtesy City Public Information/South Wedge Planning Committee files.)

SISTERS. Joyce and Deanna Stock are standing in front of Tower Lanes at Comfort and South Avenue. Frick's Funeral Home was nearby on the northeast corner. (Courtesy Josh Canfield.)

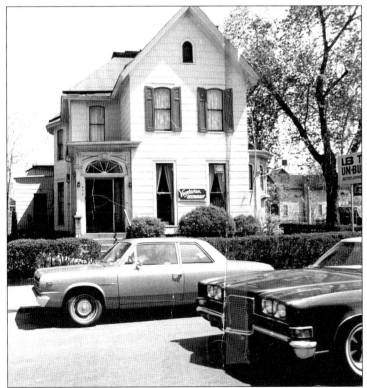

THE UN-BURGER. In the 1920s and 1930s, the Frick family lived in a house at 436 South Avenue that had been built between 1875 and 1888. Frick's Funeral Home was transformed into the Un-Burger Vegetarian Restaurant in the late 1970s. South Wedge native Josh Canfield could not bring himself to try the food because he had been to too many funerals there. It became a Christian bookstore after that. (Courtesy City Public Information/South Wedge Planning Committee files.)

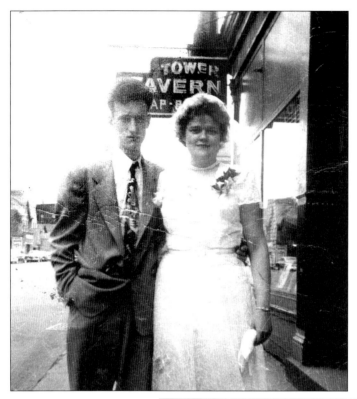

WEDDING DAY. James Canfield and his new bride, Jackie, pose on the southeast corner of Comfort Street and South Avenue by the Tower Tavern around 1952. (Courtesy Josh Canfield)

COUSINS. In this late-1950s picture in front of 100 Comfort Street are, from left to right, Millie, Sharon and Ritchie Forgue, and their cousins Tom and Josh Canfield. (Courtesy Josh Canfield.)

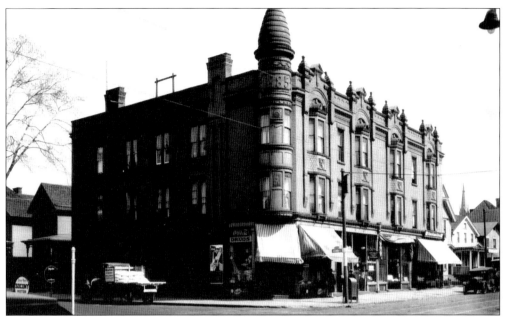

APARTMENTS, 1920. This solid building, constructed in 1885, was on the southeast corner of South Avenue and Alexander Street. (Courtesy Rochester Public Library.)

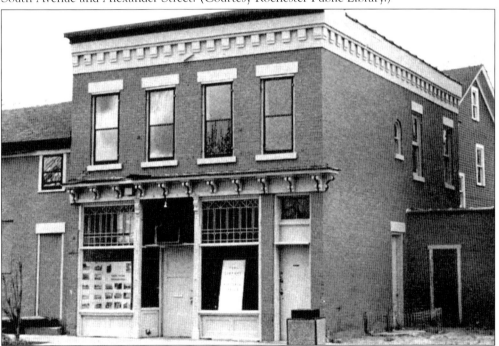

HISTORICAL OFFICE. The South Wedge Historical Office, South Wedge Tool Library, and the *Wedge* newspaper were once located at 489 South Avenue. On July 21, 1984, the office was headquarters for a South Wedge house tour. In the tour booklet, the *Wedge* was described as a joint venture of the South Wedge Planning Committee, Oakland Park Neighborhood Association, and South Wedge Acting Together (SWAT) and was published monthly. (Courtesy Josh Canfield.)

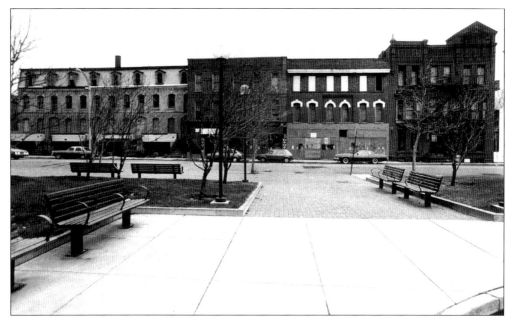

The Old Burch Building. The Burch Building, shown to the far right on December 12, 1979, was destroyed by a fire in 1981. To the far left, the so-called Green Monster was actually the Plaza Apartments. They are seen across from the Southview Towers apartments, at 500 South Avenue. (Courtesy South Wedge Planning Committee files.)

Gas Station. Marlene, Junior, and Deanna pose for the camera across from one of the two gas stations on South Avenue; this one was on the northeast corner of South and Alexander Street decades before the Southview Towers were built. Some neighbors can remember when the other gas station blew up in the 1970s. It was on the northwest corner of South Avenue and Averill. (Courtesy Josh Canfield.)

UGLY DUCKLING. This vacant lot on the southeast corner of South Avenue and Alexander Street went through regular improvements in the 1980s and 1990s as an urban green space across from Southview Towers. After years of effort, the South Wedge Environmental Enhancement Project (SWEEP) rounded up $225,000 of funding and, in 2004, turned the green space into the future Nathaniel Square. (Courtesy South Wedge Planning Committee files.)

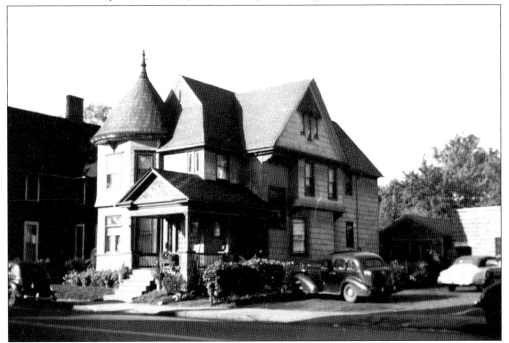

PRE-PURPLE PAINT. The house at 515 South Avenue is shown in the 1950s before it became famous in the 1980s as Mark and Karen Caulfield's purple "Painted Lady."

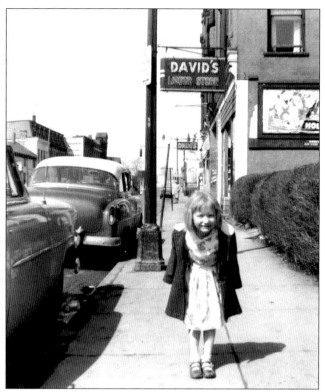

TAKING A BOW. Little Sharon Forgue takes a bow in front of 516 South Avenue. (Courtesy Josh Canfield.)

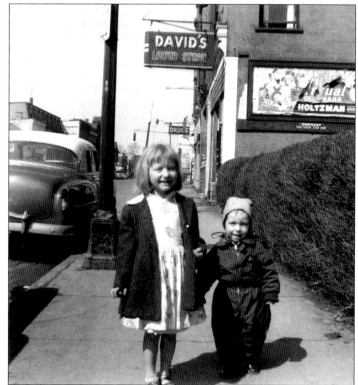

HOLDING STILL. Sharon and Ritchie Forgue pose by 516 South Avenue in the 1950s. The Green Monster is to the left in the background. (Courtesy Josh Canfield.)

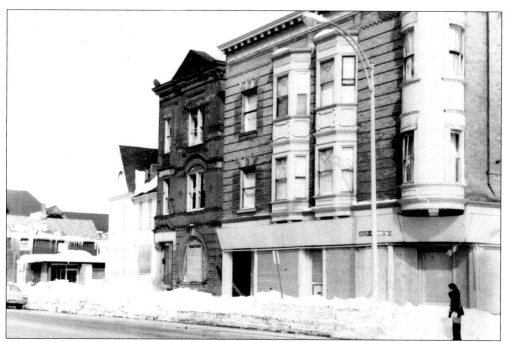

SEEN BETTER DAYS. This rare, three-story brick row house at 540 South Avenue was built in 1890. It was vacant for eight years before it became home to Historic House Parts in 1980. The old apartments at the northeast corner of South Avenue and Hamilton Street did not survive. (Courtesy Josh Canfield.)

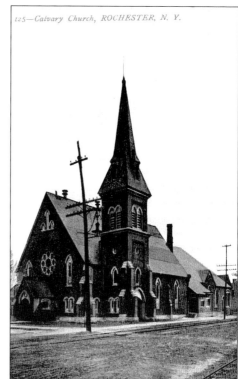

CALVARY CHURCH. There was a small Presbyterian congregation at South Avenue and Hamilton Street from around 1850 until 1964. The church was torn down for a housing project that was never completed. This postcard was printed by Scrantom Wetmore and Company of Rochester and printed in Germany before transatlantic business stopped during World War I. This card dates from between 1905 and 1910. (Courtesy George Varga.)

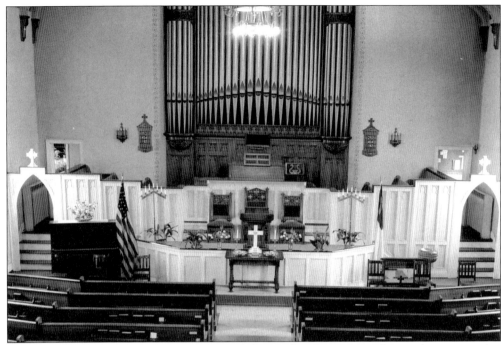

SANCTUARY AND ORGAN. The interior of Calvary Church is immaculate and serene in this undated picture. (Courtesy Calvary St. Andrew's Church.)

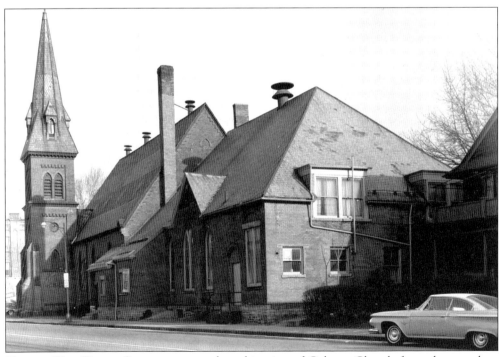

CLASSIC TWO-DOOR. Car experts can date this view of Calvary Church from the two-door oldie on the right. (Courtesy Calvary St. Andrew's Church.)

OPEN SPACE. The entire block along South Avenue between Hamilton Street and Averill Avenue was undeveloped in 1979. (Courtesy City Public Information/South Wedge Planning Committee files.)

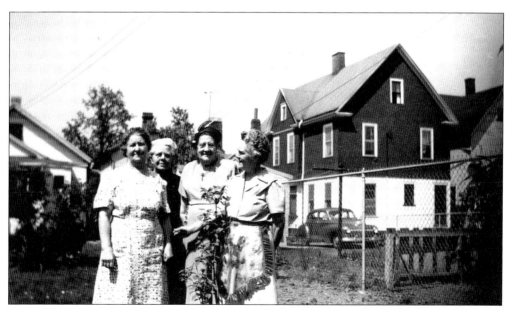

RUBY MURPHY. The woman on the far right, Ruby Murphy, is shown in her backyard on Averill Avenue around 1950. She lived in this house until she died around age 90. Even after she could no longer plant her own garden, she had Josh Canfield put one in for her. (Courtesy Josh Canfield.)

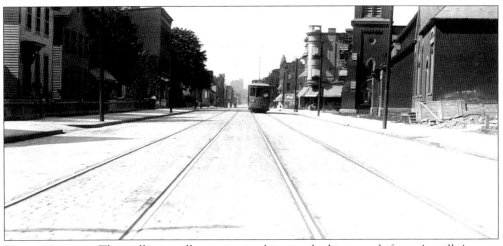

SOUTH AVENUE. The trolley is still running in this view looking north from Averill Avenue on August 13, 1913. (Courtesy Rochester City Archives.)

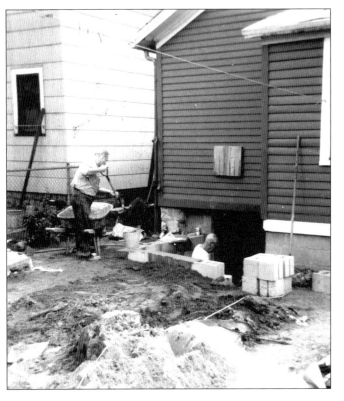

STRONG BACKS. This photograph shows John Smith and his brother-in-law, owner Frank Allen, building a foundation under the rear section of 114 Averill Avenue in the early 1960s. Tom and Josh Canfield, ages 13 and 12 respectively, dug out the basement and carried the dirt three houses over to fill in a low backyard. They found a souvenir from the "Rochester State Fair of 1851" and a brick walkway two feet below the yard's surface. Under the bricks was a large American cent, dated 1848, in near-mint condition. It was placed there by the builder of the walk. (Courtesy Josh Canfield.)

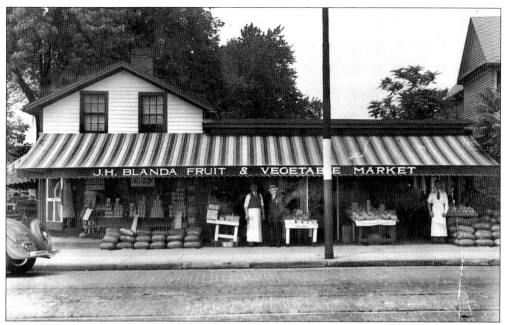

CORNER MARKET. Blanda's Fruit and Vegetable Market, on the corner of Averill and South Avenues, is shown around 1925. Among other things they sold inside the store were penny candies. The man on the far right is John Curran, who started Curran Funeral Home on Oxford Street. (Courtesy Rosemary Blanda.)

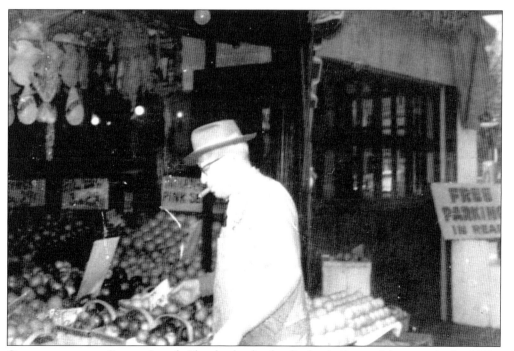

GRANDPA AT THE STORE. Joseph Blanda checks the display in front of the store in the 1920s. (Courtesy Rosemary Blanda.)

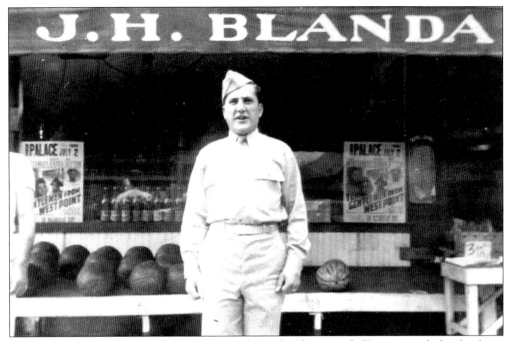

PROUD VETERAN. Dominick Termotto, whose family owned Termotto wholesale fruits and vegetables on Averill Avenue, stands in front of Blanda's in the 1940s. (Courtesy Rosemary Blanda.)

TREELESS. There is not a tree to be seen from the southeast corner of South Avenue at Averill Avenue to the Fine Arts Theatre in the distance. (Courtesy City Public Information/South Wedge Planning Committee files.)

Six

AROUND SCHOOL 13

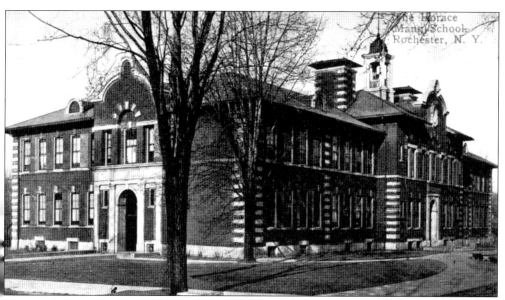

HORACE MANN SCHOOL 13. The Munger School first met in rented rooms on Hickory Street. In 1842, the first wooden schoolhouse built on Hickory Street became Horace Mann School 13. A new building was constructed in 1845 and was expanded in 1852. Another new school for 250 pupils was dedicated in June 1853. Due to the influence of Frederick Douglass and others, the city school board designated School 13 as an integrated school in the 1850s before statewide integration was enacted. Frederick and Anna Douglass's younger children attended the school for a few years. An addition was built in 1867 and remodeled and expanded several times before 1889. In 1893, a new school was built. A wood-frame and brick building, designed by J. Foster Warner, was built in 1903–1904. In 1950, after two houses were torn down, a narrow strip of land parallel to the school was leased to the board of education for a playground. Because the neighborhood was so crowded, the lily pond in Highland Park was converted into a playground in 1951. A new wing was added in 1955. This postcard was printed between 1905 and 1910. (Courtesy Josh Canfield.)

NAME *David Canfield*

KINDERGARTEN
PROGRESS REPORT TO PARENTS

SCHOOL *#13*

TEACHER *Miss J. Arment*

PRINCIPAL *Sophia W. Greffrath*

SCHOOL YEAR 19_54_ - 19_55_

TO PARENTS:

Many parents and teachers have felt that the report card which we have used did not tell quite enough about each child's growth and development. This new and less formal card has been designed to give the parent more complete information concerning the progress of each child in the varied aspects of school life. It is hoped that it will give you a better understanding of your child's abilities and needs so that you may encourage him to continued improvement.

We want your child to be happy in his school work and, at the same time, to reach his best level of achievement. Believing that a child makes his best progress when the home and the school work together, we invite you to visit the school to talk with your child's teacher and principal.

JAMES M. SPINNING
Superintendent of Schools

BOARD OF EDUCATION
ROCHESTER, NEW YORK
ELEMENTARY SCHOOLS

Item # 63A

REPORT CARD. In his 1955 kindergarten report from School 13, Mrs. Canfield wrote in the parent's comment box, "David thinks you are the very best teacher."

ANOTHER GRADUATION. In 1959, Marie Daley became principal at Horace Mann School 13. She retired from there in 1963 after 35 years with the Rochester city school district. Here she stands with Patricia Wurzer of Gregory Street in June 1966. (Courtesy Bruce Butler for Marie Daley.)

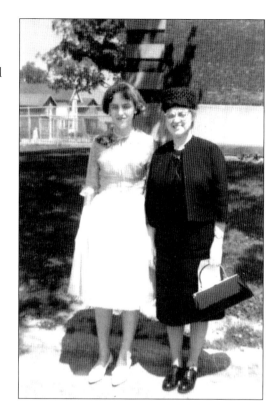

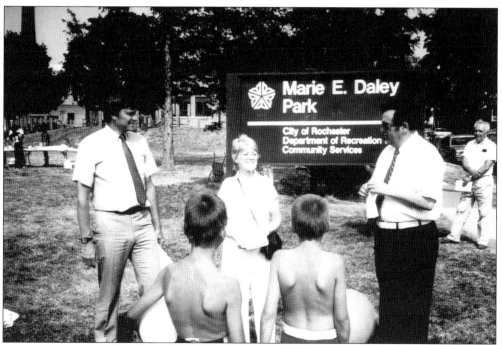

PARK DEDICATION. Marie Daley was honored on July 15, 1983, when the city of Rochester dedicated the park on Gregory Street to her. (Courtesy South Wedge Planning Committee files.)

GRANDMA'S FUNERAL. This lavish display was held in the front parlor of 213 Gregory Street for a beloved mother and grandmother. Elizabeth Schleyer is listed at 95 Gregory Street in 1899 and at 213 in 1902 after the street numbers changed. Elizabeth Schleyer, widow of Joseph, lived

ROBERT BRANDOW. The builder of 217 Gregory Street, Robert M. Brandow, was a Civil War veteran who lived at the house from 1913 until his death at age 87 in 1932. (Courtesy Chris Dorn.)

at 217 Gregory Street in 1928. The back of this photograph was stamped, "Pictures Framed to Order by G. J. Stage. 11 Grand St. Rochester, N.Y." (Courtesy Chris Dorn.)

GRAND ARMY OF THE REPUBLIC PLOT. Robert Brandow's name is barely legible on the tombstone in the Grand Army section at Mount Hope Cemetery. He joined at age 17, serving in the 8th New York Independent Battery from January 1863 to June 1865. (Author's collection.)

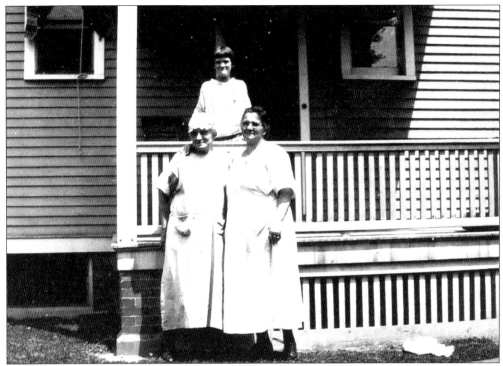

LIVING AT 217 GREGORY STREET. Also living at 217 were Robert Brandow's companion, Anna Schleyer (Augusta Schleyer's grandmother), and Walburga Schleyer (Christine Dorn's grandmother). Anna died in 1939. Shown on the back porch is a young "Aunt Bessy" Schleyer. Standing in front are Walburga Schleyer and possibly her sister, Annie. Walburga was said to have slept year-round on the open porch upstairs. (Courtesy Chris Dorn.)

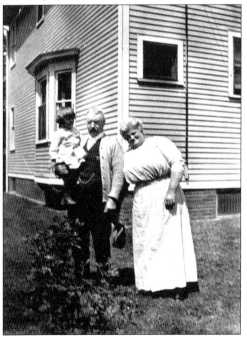

MRS. JOYCE. This undated photograph taken behind 217 Gregory Street identifies only Mrs. Joyce and son, making no mention of the man. (Courtesy Chris Dorn.)

BESSY. A teenage Bessy Schleyer calls out, possibly in front of the old East High on Alexander Street. (Courtesy Chris Dorn.)

AFTERNOON SNACK. This group of schoolgirls is enjoying a snack on the porch under the watchful eye of Grandma Walburga Schleyer. (Courtesy Chris Dorn.)

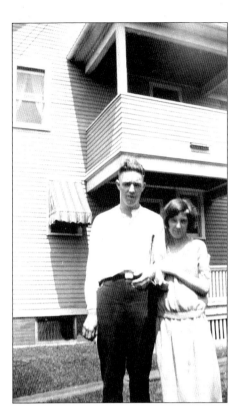

CLARENCE AND BLANCHE. Clarence Schleyer and his wife, Blanche, shown in the backyard at 217, were listed in the 1929 city directory as having a house at 102 Gregory. (Courtesy Chris Dorn.)

MR. O'BRIEN. The Schleyers rented 213 Gregory to Mr. O'Brien in the 1920s. Mr. O'Brien stands with his shirtsleeves rolled up while the girls from 217, Augusta (Chris's mother) and Gertrude Schleyer, are dressed for skating. (Courtesy Chris Dorn.)

MISS SCHLEYER. At least two generations of students learned Latin and English at Monroe High School from Elizabeth Schleyer. (Courtesy Chris Dorn.)

CHERRY BLOSSOMS. The cherry tree next door was a springtime delight in the 1960s. This view also shows the old city carriage house attached to the garages behind 199 Gregory Street. The carriage house was torn down in 2004. (Courtesy Chris Dorn.)

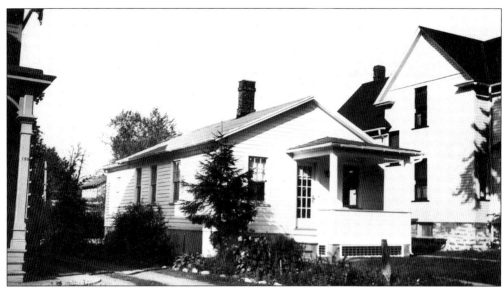

THE HOUSE AT 154 GREGORY STREET. This picture was taken shortly after the D'Hondt family moved into the house around 1936. The house was later torn down to make room for a park next to School 13. (Courtesy Kathy Englerth.)

PROUD PAPAS. Great-grandfather James Todd poses proudly behind 154 Gregory Street in 1947 next to George D'Hondt, who is holding his three-month-old baby, Kathy. (Courtesy Kathy Englerth.)

ANNUAL PICNIC. Vince Corsall, Marie Daley, and Mack McDowell all became honorary members after serving on the South Wedge Planning Committee board for 10 years. They are shown here enjoying the day at the summer picnic in Marie Daley Park, held annually for about 10 years. Vince wrote about his family for the *Wedge* newspaper. He was born prematurely and was baptized three times, first at birth, again when he came out of incubation in the family oven, and later in church. Vince's brother Sam worked at Blanda's Corner Market, which was open all night. During his teens, Vince worked at his uncle Vince Giambrone's store. Customers called in their orders, and the young Vince delivered them. He relates how he had to walk through the work area of the funeral parlor at South and Comfort Streets. After seeing a body sitting up once, Vince refused to make any more deliveries there. (Courtesy South Wedge Planning Committee files.)

PITCHING IN. Bill Lauterbach and Marie Daley get ready to dig in at the tree-planting ceremony in their honor on May 25, 1995. (Courtesy Bruce Butler.)

CHRISTMAS CHEER, C. 1954. This handmade Christmas card features 233 Gregory Street. The brick Federalist house was built in stages starting around 1860. (Courtesy Nancy B. B. Meyer.)

NEIGHBOR GIRLS. Seven-year-old Nancy Meyer (front left) poses with the Fromm girls, Christine (front right), Mary Beth (rear left), and Andrea (rear right), in 1954. (Courtesy Nancy B. B. Meyer.)

Seven

AROUND SOUTH
AND GREGORY

ENGINE COMPANY NO. 8. This picture from 1900 shows large wooden doors on the fire station. George G. Sauer of 29 Gregory Street was listed as a foreman at Hose Company No. 8 in the 1899 city directory. The fire station is listed at 357 Gregory Street in the 1902 directory. There were 29 Sauers listed in 1902, including Helen (a tailor at 183 Gregory Street), Henry (a carpenter at 42 Gregory), Jacob (of S-K Cigar Box Company at 65 Hickory), and John (a carpenter at 183 Gregory). (Courtesy Rochester Public Library.)

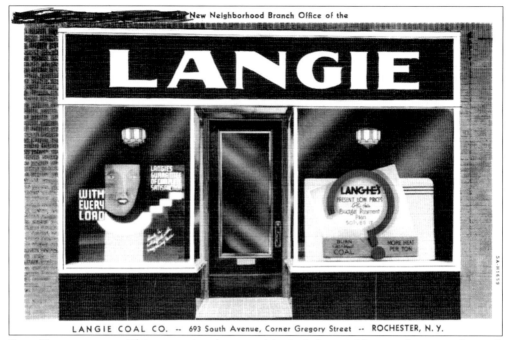

LANGIE COAL CO. -- 693 South Avenue, Corner Gregory Street -- ROCHESTER, N. Y.

FREE THERMOMETER. This promotional postcard invited the neighbors to drop in to Langie's new location at 693 South Avenue, on the corner of Gregory Street. After Langie's, a series of other business occupied this building, including Miller's Bakery, Michael's Restaurant, and Café Zeppa del Sud. (Courtesy Josh Canfield.)

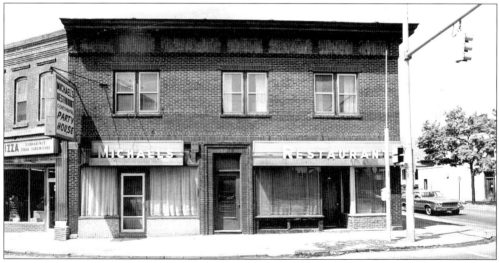

MICHAEL'S. Michael's Restaurant and Party House was very popular in its day. This view is from the 1970s. (Courtesy South Wedge Planning Committee files.)

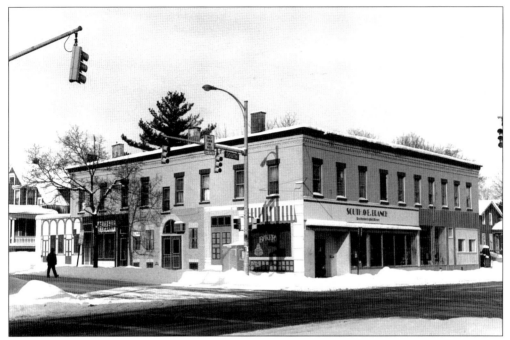

LIBRARY MURAL. After the South Avenue branch library burned down, the library was relocated to the old Abeles Building on the northwest corner of South Avenue and Gregory Street. The cheerful mural painted on the south side of the building is fresh and new in this 1982 photograph. (Courtesy South Wedge Planning Committee files.)

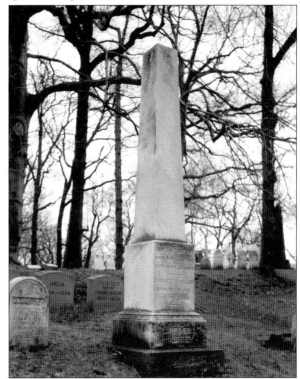

GREGORY CONNECTION? The 1900 city map (plate No. 27) shows a large "Gregory Tract" property from South Avenue to South Clinton, but the western side of Gregory Street was named on the map of 1857. James H. Gregory, who died in 1869 and was buried in Mount Hope Cemetery, was a farmer, real-estate agent, Democratic nominee for mayor in 1849, and leader in the Monroe Temperance Service. He lived on Alexander Street.

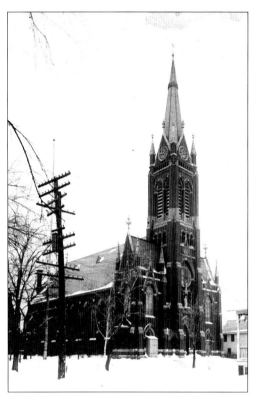

ST. BONIFACE. The church dedicated to the "Apostle of Germany" was founded in 1860 in response to the arrival of many German immigrants. The German Roman Catholic School was founded in 1861. A three-story brick building on Grand Street, dedicated in June 1861, was used for a rectory, school, and church. The early Gothic-style church was dedicated on December 18, 1887. It had a spire 195 feet tall and seating for 1,000. This postcard is from around 1900. (Courtesy Josh Canfield.)

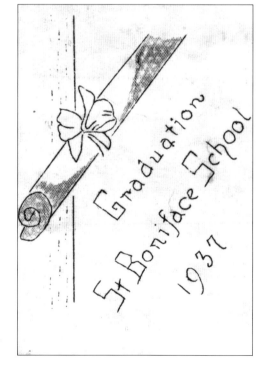

CLASS OF 1937. There were 54 names listed in the St. Boniface School graduation program for 1937, with honors conferred by Msgr. John F. Boppel. The piano was provided by Levis Music Store. (Courtesy Chris Dorn.)

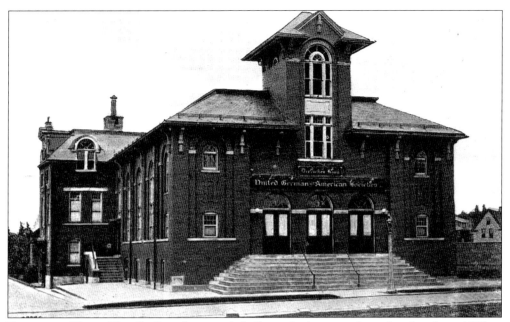

DEUTCHES HAUS. The St. Boniface parish hall was built across from the church in 1908 to be used as a school and gymnasium. This postcard of Deutches Haus, of the United German-American Societies, was published by the Rochester News Company after the church sold the building in 1924. The Historic German House was restored and reopened by Ron and Norma Maier in September 1987. (Courtesy George Varga.)

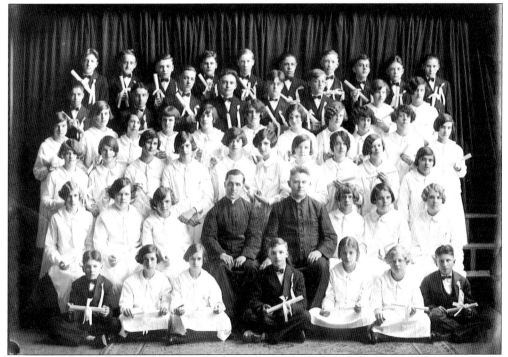

CLASS OF 1921. Fr. George Schmitt and Msgr. John Boppel pose indoors with the class of 1921. (Courtesy St. Boniface Church.)

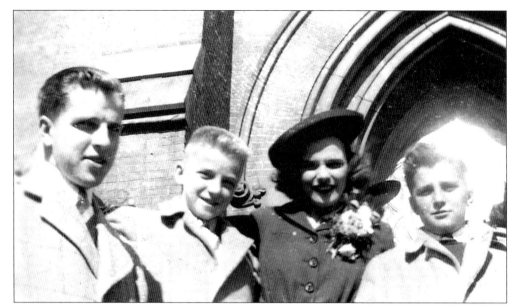

WEDDING BELLE. Jeannie Ehmann (Newcomb) stands with her brothers Bernie, Paul, and Carl Ehmann outside St. Boniface on her wedding day in 1942. Her sister Helene Ehmann Honadle, who has lived on Linden Street for over 50 years, shared the family photograph. Helene was born on Linden Street between South Clinton and South Goodman when it was called Yale Street. She has lived in dozens of homes in the southeast part of the city. She is a lifelong member of St. Boniface. (Courtesy Helene Honadle.)

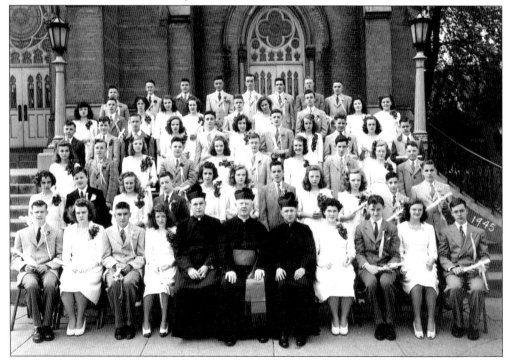

READY AS CAN BE. The class of 1945 poses in front of the church, looking as ready as can be to meet their future. (Courtesy St. Boniface Church.)

THE SCHOOL. This undated photograph shows a small lawn and path from Weider Street. (Courtesy St. Boniface Church.)

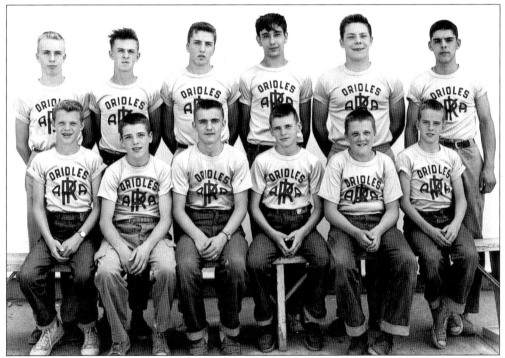

PLAY BALL! Most of the 1954 St. Boniface Orioles team look ready to win. (Courtesy St. Boniface Church.)

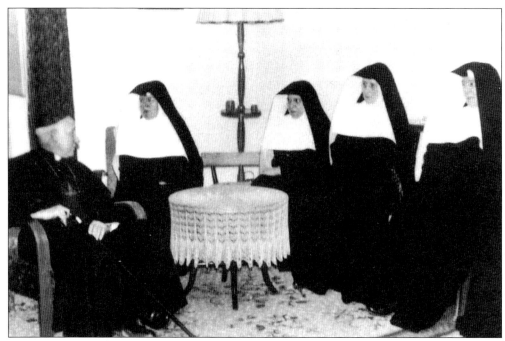

FORMAL VISIT. Bishop Kearney met with the sisters at the convent in the 1950s. (Courtesy St. Boniface Church.)

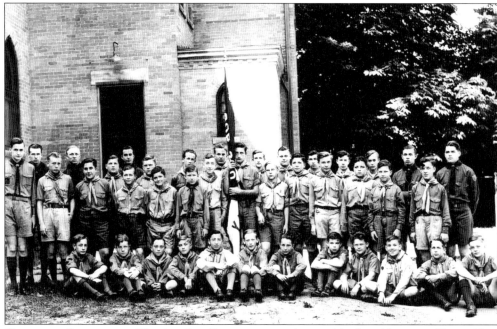

KIND AND COURTEOUS. The first Boy Scout troop in the neighborhood began as Troop 28 at St. Andrew's Church in the 1930s. Eventually, another group of Scouts branched off to form Troop 200 at St. Boniface. The area outside the back of the rectory was still unpaved when Boy Scout Troop 200 posed around 1957. (Courtesy George Varga.)

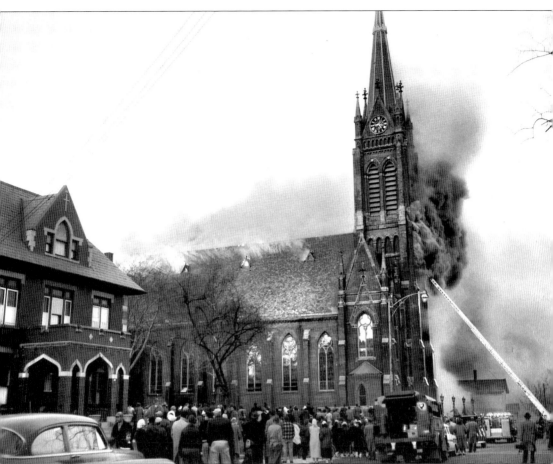

THE BIG FIRE. St. Boniface Church caught fire during repairs in November 1957. The roof was destroyed, the organ was ruined, and the walls were heavily damaged. Four bells, including the largest one (two and a half tons), were removed from the spire and put into storage. This view of the neighbors watching the beginning of the fire also shows the sisters' convent (now Becket Hall), which was built in 1900.

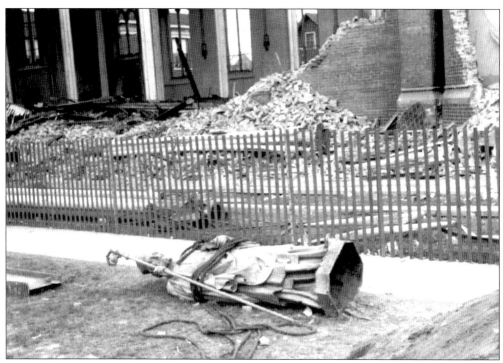

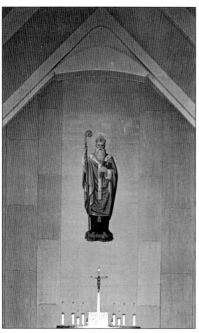

ST. BONIFACE FALLEN AND RESTORED. The statue of St. Boniface lies next to the rubble after the fire. After a drive to raise $200,000, the new church was dedicated in June 1960. (Courtesy St. Boniface Church.)

Eight
SOUTH OF GREGORY

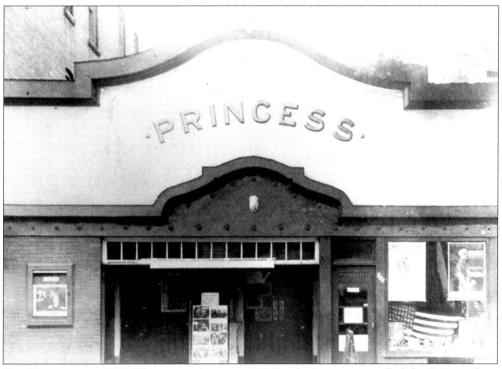

THE PRINCESS, C. 1927. The movie theater at 700 South Avenue was called the Princess from 1913 until 1929 and the Rexy from 1930 until 1954. It was closed from 1955 until 1958 and reopened as the Fine Arts Theatre in 1959. (Courtesy South Wedge Planning Committee files.)

Yourself and company are cordially

invited to attend a

MAY ✦ PARTY,

TO BE GIVEN BY

Y. ✦ M. ✦ R. ✦ C.,

AT EISENBERG'S HALL,

Cor. Pinnacle Ave. and Meigs St.

Tuesday evening, *May 24th, 1892.*

AT 8:00 O'CLOCK SHARP.

Introduced by

INVITATION, 1892. The Lauterbach family received this invitation to a card party at Eisenberg Hall. The hall was located on the corner of Pinnacle Avenue, now South Clinton and Meigs Streets. (Courtesy Robert Lauterbach.)

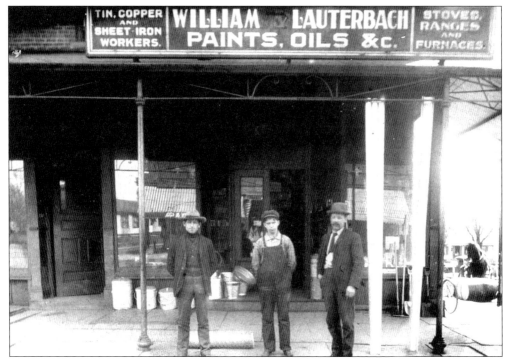

LAUTERBACH'S, 1905. William Lauterbach Sr., who founded the business in 1899, stands on the right in front of his store. (Courtesy Robert Lauterbach.)

SAVING THE HOUSE. The city of Rochester was ready to tear down 288 Sanford Street in the 1980s after it had been ruined by a fire. Rev. Judy Lee Hay rescued it from demolition. Hay served as executive director of the South Wedge Planning Committee for 16 years, ending in 1991. Volunteers worked on repairing the house for years. It was reopened in 1992 as the South Wedge Planning Committee offices and home of the South Wedge Tool Library. (Courtesy Josh Canfield.)

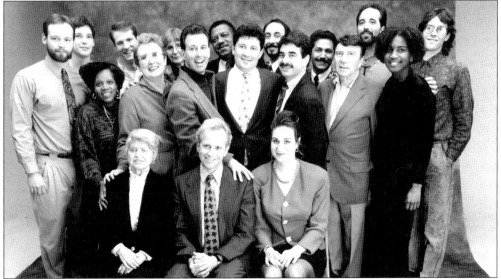

A FINE BUNCH. The enthusiastic South Wedge Planning Committee staff and board members gathered for this photograph after the move into 288 Sanford Street. They are, from left to right, as follows: (first row) Marie Daley, Ray Breslin, and Ann Eckedahl; (second row) Shawn Madden, Terisa Walker, Deborah Fae Swift, Jo DiDonato, Lou Asandrov, Loren Ranaletta, Vince Corsall, and Delicia Hill; (third row) Margaret Pine Chabowski, Jonathan Taylor, Ann Baker, Mack McDowell, Ed Raskin, Marc Brown, Mitchell Danneberg, and Phil Stukas. (Courtesy South Wedge Planning Committee files.)

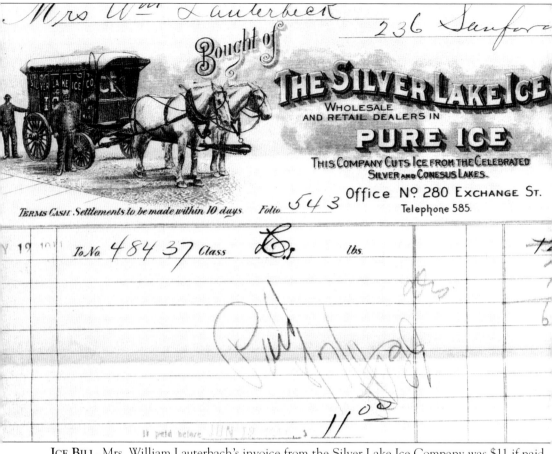

Mrs W<u>m</u> Lauterbeck 236 Sanford

Bought of

THE SILVER LAKE ICE

WHOLESALE
AND RETAIL DEALERS IN

PURE ICE

THIS COMPANY CUTS ICE FROM THE CELEBRATED
SILVER AND CONESUS LAKES.

Terms Cash. Settlements to be made within 10 days. Folio 543 Office № 280 EXCHANGE ST.

Telephone 585.

Y 19 To No 484 37 Class lbs.

If paid before JUN 19 11 00

ICE BILL. Mrs. William Lauterbach's invoice from the Silver Lake Ice Company was $11 if paid before June 18, 1911. It was discounted and paid on June 7. (Courtesy Robert Lauterbach.)

YOUNG HAROLD. William Sr. stands ready behind the counter in 1914, with tinsmith George Engel and Harold Lauterbach, age five. (Courtesy Robert Lauterbach.)

GETTING SUPPLIES. In this photograph from 1911, William Sr. is behind the counter. (Courtesy Robert Lauterbach.)

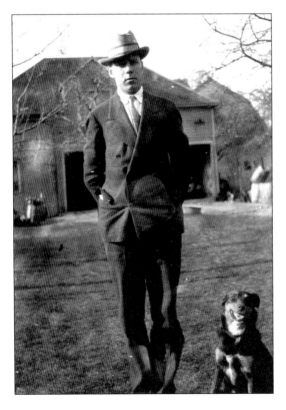

BILL AND BUSTER. Bill Lauterbach stands with his dog in 1930 in front of the carriage house at 236 Sanford Street. (Courtesy Robert Lauterbach.)

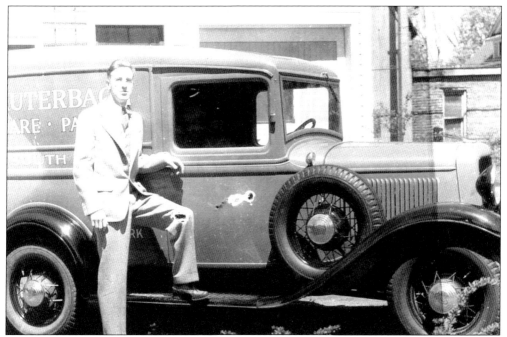

THE NEW TRUCK. Harold Lauterbach looks dressed for business by the new store truck in June 1933. (Courtesy Robert Lauterbach.)

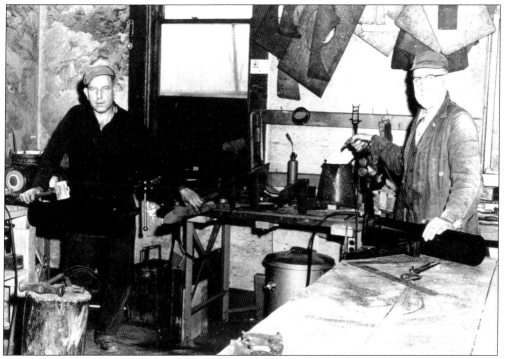

TINSMITHS AT WORK. William Schenk of Crawford Street and Fred Ahrens of Furman Crescent are seen in the back room in March 1955. (Courtesy Robert Lauterbach.)

HOUSE TOUR 1983

SATURDAY MAY 14, 1983

HOUSE TOUR, 1983. Deb Messmer was president of South Wedge Acting Together, which put on a house tour on May 14, 1983. Eight buildings were featured: 684–686 South Avenue, the new Gregory Park Condominiums, 94 Averill Avenue, 336 Averill Avenue, 100 Alexander Street, 467–483 South Avenue, 16–24 Walton Street, and 436 South Avenue. The booklet also advertised *Highland Park Iris* prints for a $100 donation to SWAT. (Courtesy Josh Canfield.)

THE BROTHERS. Bill, Harold, and Herbert Lauterbach, shown here in 1985, worked at the hardware store for decades. Frequently asked when he was going to retire, Bill would often reply, "After the 11 o'clock news." He finally retired at age 93 and died six years later, in September 2004. Harold had died years earlier, and Herbert was living in a nursing home. (Courtesy Robert Lauterbach.)

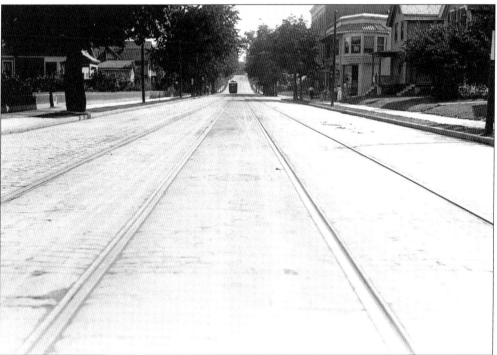

BROOM SWEPT. There is hardly a leaf out of place in this August 13, 1913, photograph of South Avenue at Caroline Street. (Courtesy Rochester City Archives.)

SOUTH SIDE SENIORS. Marie Daley and longtime friend Thelma Treble were co-leaders of the South Side Seniors from its beginnings in 1964. Marie also served on the board of the South Wedge Planning Committee from its first days in 1976. After years of community service, executive director Rev. Judy Lee Hay presented Marie Daley with a lifetime of service to humanity award in February 1983. This photograph was taken in the community room at South Avenue Baptist Church, which started in 1885 as a mission of First Baptist Church on Meigs and Benton Street. The new church was founded in 1890. (Courtesy Josh Canfield.)

NEW BUILDING. The large turtle has been a faithful playmate since Rochester Children's Nursery moved into its new building at 941 South Avenue in February 1955. (Courtesy

OLD MANSION. This picture, taken in 1890, is titled "William L. Halsey's House, 339 South Avenue." The house was built by George Ellwanger and sold in 1862 to lawyer George H. Mumford, who lived there until his death in 1871. Halsey was a businessman in railroad and banking as well as Mumford's son-in-law. The 1900 city map (plate No. 27) lists Helen M. Halsey at 941 South Avenue. The Neun family owned the old mansion from 1910 until it was torn down to make room for the new building. (Courtesy Rochester Public Library.)

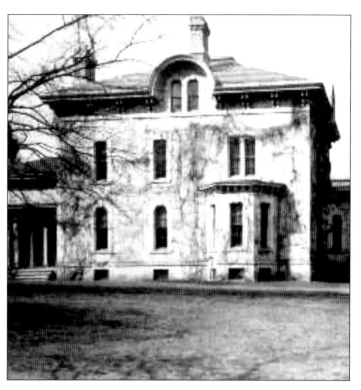

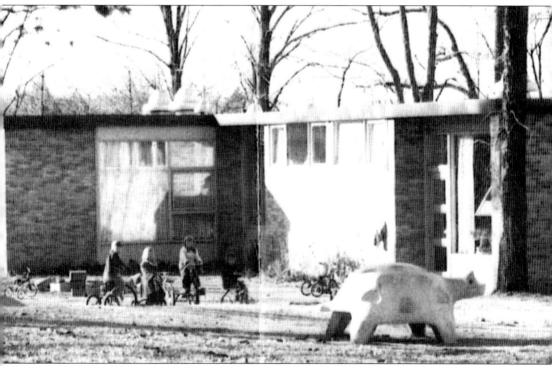

Rochester Children's Nursery.)

MRS. MOORE. Pauline T. Moore was a descendant of John W. Thompson, who is credited with having a monument built for Frederick Douglass after Douglass's death in 1895. Pauline and John Moore were leaders among Rochester's oldest black families. Despite having earned a teaching degree in 1912, Pauline was not able to find work in Rochester. After World War II, she helped found the Carver House Nursery. Rochester Children's Nursery was still on Exchange Street when the two merged in the late 1940s. Pauline worked at the nursery from 1947 to 1974. In addition to raising five sons and five daughters, she was also an organist and pianist at St. Simon's Episcopal Mission. In 1993, her picture was mounted on the wall of the nursery's conference room when a scholarship fund was created in her name. (Left and below courtesy Jackie Hopkins.)

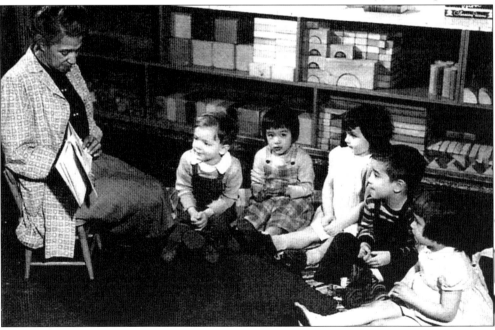

NEW MARKER. After about eight years in their home on Alexander Street, Frederick Douglass, his wife, Anna, and their five children moved to South Avenue in 1855. The children were Rosetta (born 1839), Lewis (born 1840), Frederick Jr. (born 1842), Charles (born 1844), and Annie (born 1849). They bought a house and barn on a six-acre wooded plot on South Avenue (now 1023 South Avenue). The house was located nearby where the lily pond at Highland Park is today. In June 1872, when their home caught fire, neighbors helped carry out books, furniture, and a piano, but the house burned to the ground. The fruit trees were destroyed and their money lost. The Douglass family moved to Washington, where Frederick became active in President Grant's 1872 reelection campaign. Douglass helped make Rochester the center of the antislavery movement and is considered the first Rochester resident to achieve the distinction of national and international fame. Among other local places, the Underground Railroad flourished at his office at 25 Buffalo (Main) Street, his home at 4 Alexander Street, and his later home at 1023 South Avenue. This new marker was placed on 999 South Avenue in February 2005. It was a cooperative venture of the Freedom Trail Commission and the Landmark Society. (Courtesy Robert P. Meadows.)

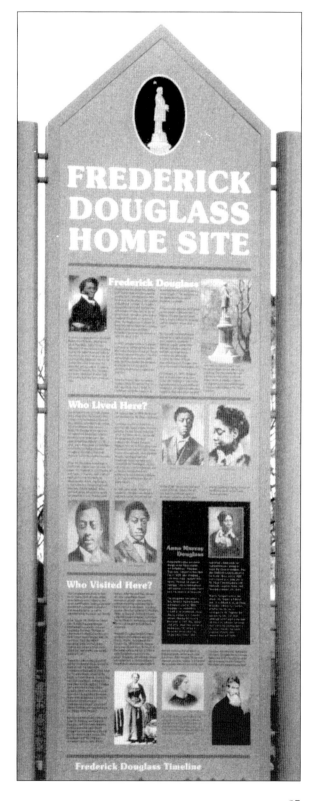

BOTTOM OF THE HILL. The hill looks deceptively smooth and easy in this southward view of South Avenue. The photograph was taken from Bellevue on August 13, 1913. (Courtesy Rochester City Archives and Rochester City Photo Lab.)

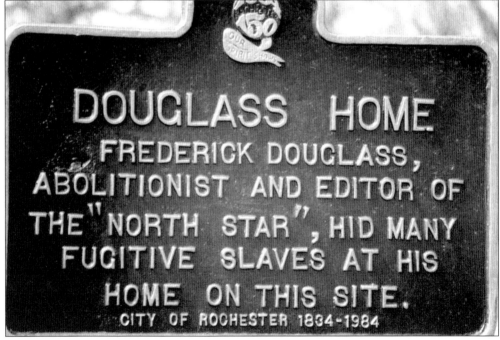

DOUGLASS HOME.

FREDERICK DOUGLASS, ABOLITIONIST AND EDITOR OF THE "NORTH STAR", HID MANY FUGITIVE SLAVES AT HIS HOME ON THIS SITE.

CITY OF ROCHESTER 1834-1984

TOP OF THE HILL. This marker stands at the corner of South Avenue and Robinson Drive, across from the statue of Frederick Douglass in Highland Park Bowl. (Courtesy Robert P. Meadows.)

Nine

SOUTH CLINTON

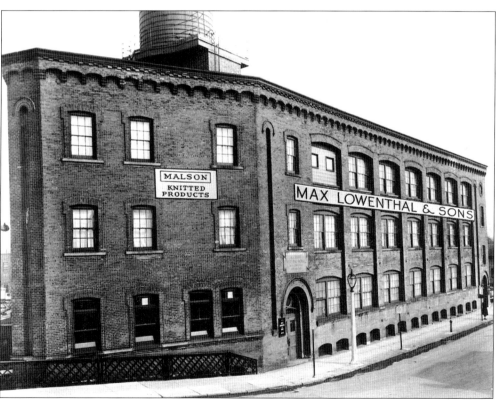

KNITTING FACTORY. Max Lowenthal and Sons built this factory along the original Erie Canal between 1900 and 1910. The factory supplied the first mittens sold to the Woolworth Company. This view was taken around 1930. The Association for the Blind and Visually Impaired (ABVI)-Goodwill Industries of Greater Rochester bought the building in 1912. (Courtesy ABVI-Goodwill.)

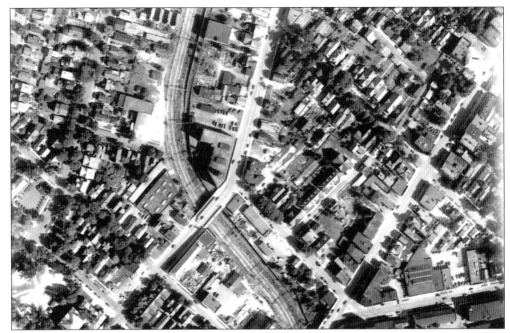

BIRD'S-EYE VIEW. The above aerial view of Rochester, taken in 1938, shows the Lehigh Valley Railroad freight station in the far lower right and the Max Lowenthal building between South Clinton Avenue and the subway bed in the center. The image below (from a postcard sent in 1963) shows the expressway from downtown past the Cobbs Hill Reservoir. (Above courtesy New York Museum of Transportation collection; below courtesy Josh Canfield.)

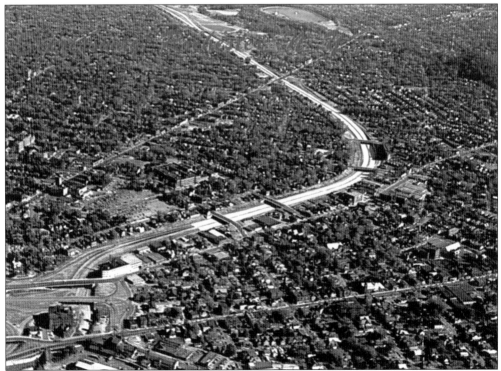

SOUTH CLINTON, 1913. Both of these photographs are dated August 13, 1913. The view above faces south from Howell Street, and the other faces south from Averill Avenue. (Courtesy Rochester City Archives and Rochester City Photo Lab.)

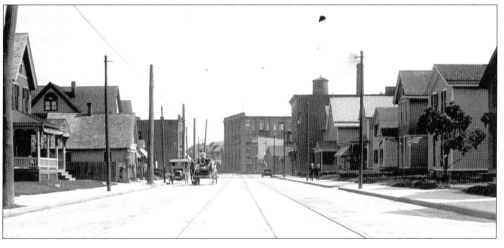

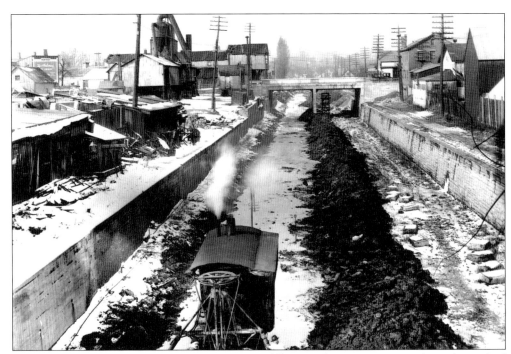

ALEXANDER STREET BRIDGE. Despite icy puddles, work continues on the subway bed construction in the 1920s. Note the faint poplar tree in the distance. A Bartholomay ice cream sign is to the far left. Bartholomay was a large brewery that switched to making ice cream during Prohibition. In the photograph below, the tracks run under the bridge on the left and almost reach the bridge on the right. (Courtesy New York Museum of Transportation collection.)

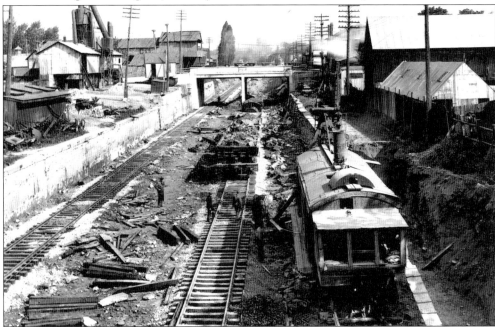

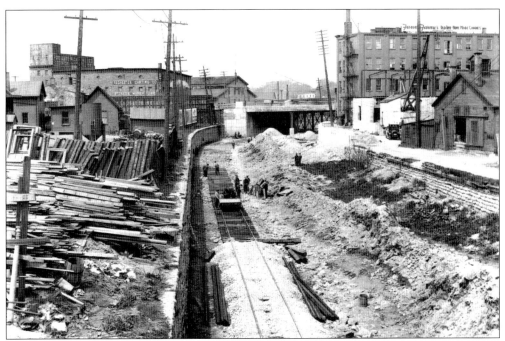

ALMOST THERE. The subway bed construction progresses toward downtown. The closeup shot of the tracks and overpass shows the Rochester Carting Company at the Stone Warehouse clearly on the left and a Fanny Farmer truck to the right. The number one Fanny Farmer store in the country opened on Main Street in 1919. The Fanny Farmer candy "studio," as it was called, at South Avenue and Seven Griffith Street was acquired at that time. The Rochester headquarters were located there until they closed in 1968. The building burned down in 1977. (Courtesy New York Museum of Transportation collection; courtesy local history division files, Rochester Public Library.)

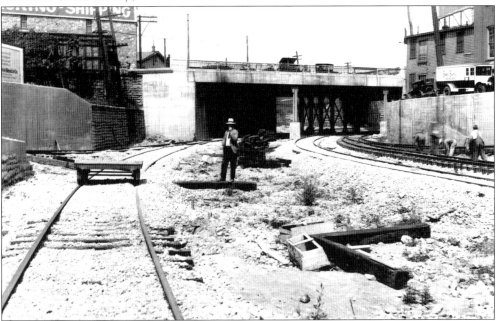

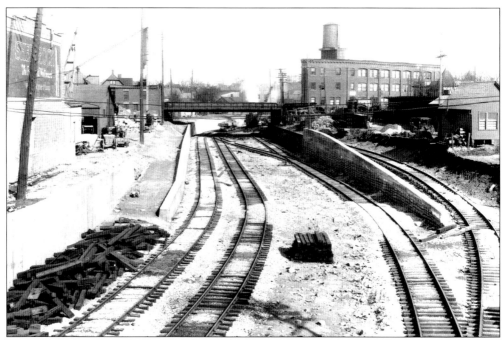

LOOKING EAST. This picture is labeled "looking east from South Avenue towards Clinton Street bridge." Notice the stone and cement retaining wall and the unfinished embankment by the house to the far right. (Courtesy New York Museum of Transportation collection.)

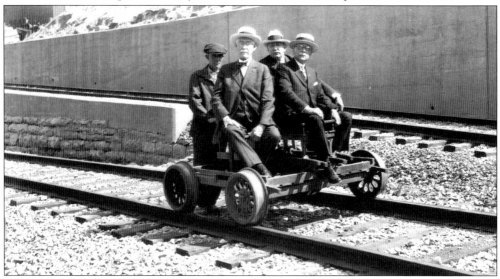

IMPORTANT INSPECTION. The four men pictured here on a hand car are, from left to right, an unidentified worker, Edwin A. Fisher (the city engineer who conceived the entire project), John O'Connor (chief project engineer), and Clarence Van Zandt (Republican mayor of Rochester). They sit by the completed retaining wall, closer to the same house that was shown in the previous picture. The last barge left downtown in 1919. Work began inside the city in 1922, and the first passenger run was made in September 1927. (Courtesy New York Museum of Transportation collection; information from *Canal Boats, Interurban and Trolleys: The Story of the Rochester Subway*, published by the Rochester chapter of the National Railway Historical Society, 1985.)

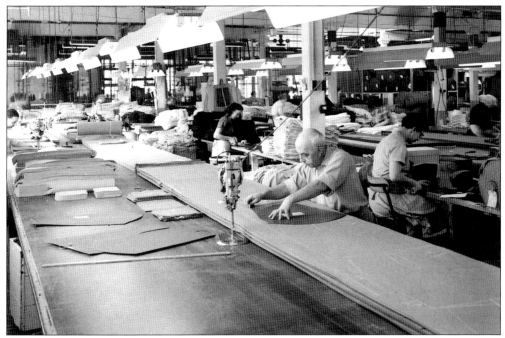

AT WORK. A man and woman are absorbed in their work at Max Lowenthal Knitting Factory in 1943. (Courtesy ABVI-Goodwill.)

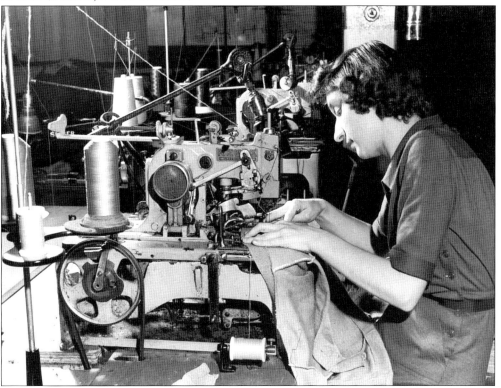

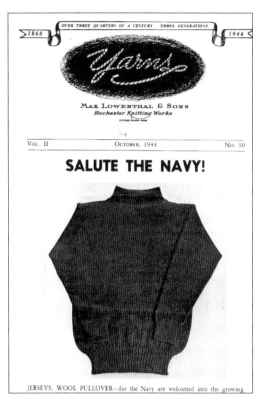

SALUTE THE NAVY!

JERSEYS, WOOL PULLOVER—for the Navy are welcomed into the growing

SALUTE THE NAVY! This company newsletter from October 1944 includes an employee news column entitled "Knit Knacks." The article includes updates on those in the service, trivia about wool, the sixth war loan drive, birthday greetings, and a profile of a 40-year employee. (Courtesy Josh Canfield.)

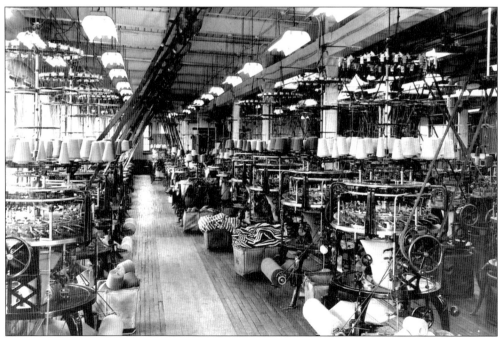

CLEAN AND QUIET. This photograph shows the interior of the factory in 1943. (Courtesy ABVI-Goodwill.)

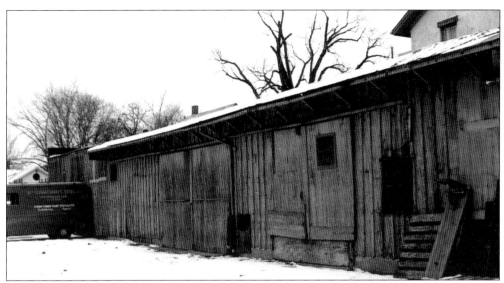

BUILT IN 1822. The William Summerhays company moved from Spring Street into these wooden storage buildings along the original Erie Canal in 1822. The company was incorporated in 1854. The stucco house was first built as a home and later utilized as a funeral parlor. Bodies were brought through the doors at the rear left in the U-shaped storage buildings along Averill Avenue. These photographs were taken in 1986 before the fire of 1988, in which they lost many early records. (Courtesy William Summerhays Inc.)

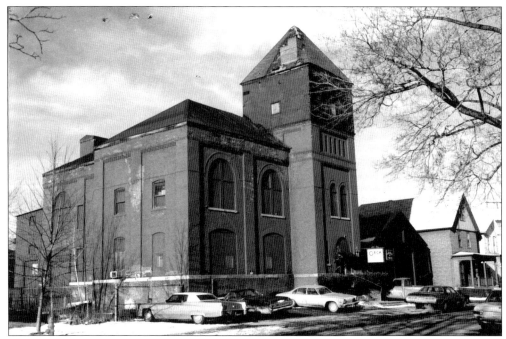

FIRST 23 SCHOOL. The brick building at 336 Averill Avenue and Bond Street, shown here in 1980, was built in 1884 as City School 23. Although the building was designed so that a wing could be added if enrollment increased, it was only used as a school until 1902. After it was sold, the building housed a succession of different business, including a broom factory, two different sign companies, and plumbing supply business. (Courtesy Landmark Society/South Wedge Planning Committee files; information from *South Wedge Acting Together, 1982 House Tour* booklet.)

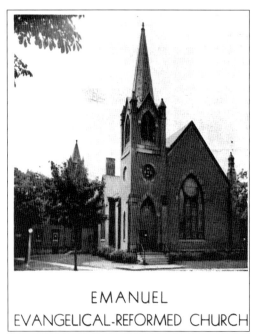

EMMANUEL CHURCH. Emmanuel German Evangelical Reformed Church separated from the Roman Catholic Church in 1848 and built a church downtown around 1851. The congregation relocated to Hamilton and Bond Streets in 1867. This picture is from a 1952 centennial observance booklet. The church was destroyed in a fire. (Courtesy Lea Buzby.)

Ten

ANCESTORS
AND NEIGHBORS

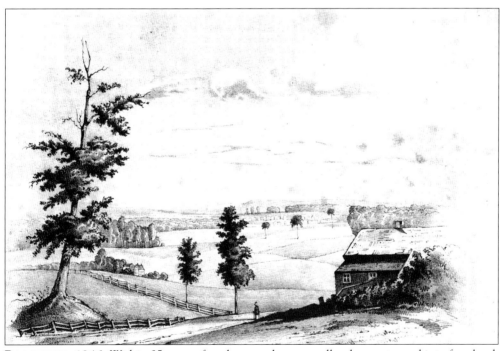

ROCHESTER, 1846. Within 35 years of settlement, dense woodlands were turned into farmland. *Rochester as seen from Mount Hope Cemetery* was created in 1846 by Ebenezer Emmons Jr. (Courtesy Rochester Public Library.)

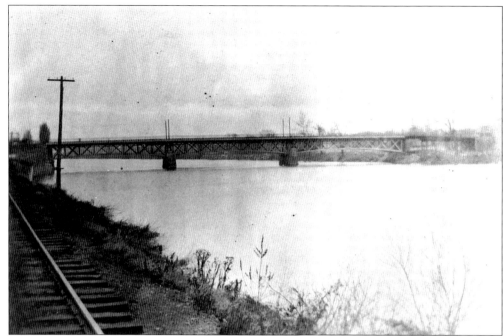

THE BRIDGE. This is a view of the bridge from the southwest bank. The photograph was taken on December 7, 1892. (Courtesy Rochester City Archives and Rochester City Photo Lab.)

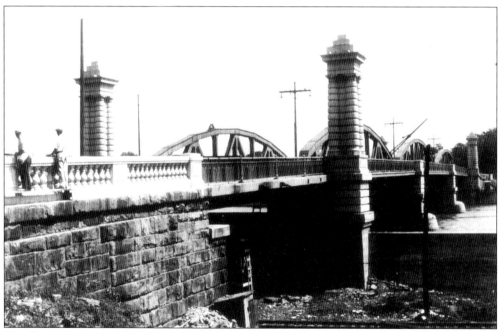

THE BRIDGE, C. 1935. It appears that the Clarissa Street bridge was being painted or repaired when this photograph was taken around 1935. (Courtesy Rochester City Archives and Rochester City Photo Lab.)

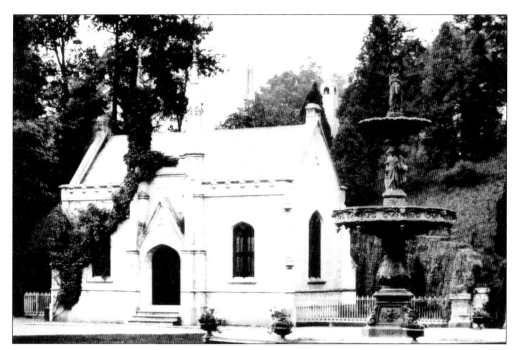

CHAPEL AND FOUNTAIN.
Mount Hope Cemetery, the first municipal Victorian cemetery in the United States, was dedicated on October 3, 1838. It was modeled after early-19th-century rural garden cemeteries in Europe. A Gothic Revival chapel designed by local architect Henry Robinson Searle was built in 1862. The Florentine fountain was cast in 1875. (Above courtesy Rochester City Photo Lab; right courtesy Robert P. Meadows.)

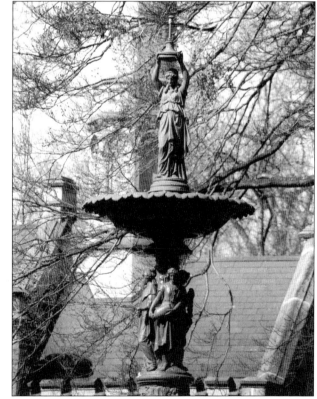

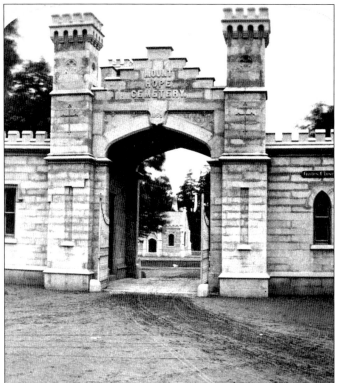

GOTHIC REVIVAL ENTRANCE. The first gatehouse was a wooden, Egyptian-style structure that was replaced in 1859 with a stone one. It was too narrow and was demolished around 1872. The current entrance gate and gatehouse were built in 1874. (Courtesy Josh Canfield.)

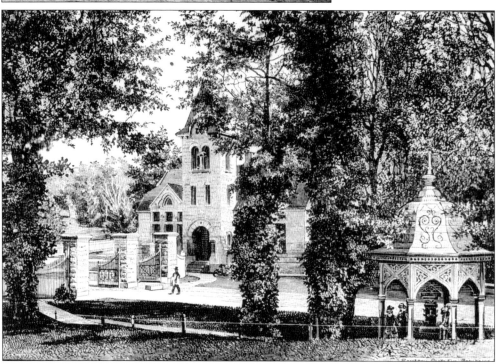

GAZEBO AND GATEHOUSE. The Moorish Revival gazebo was built to house a water fountain, shown in this undated illustration. (Courtesy Rochester City Photo Lab.)

SMALL GATE. Winter still has its hold in this view dated March 2, 1938. (Courtesy Rochester City Photo Lab.)

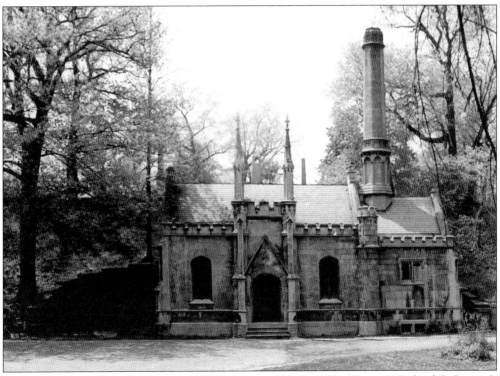

CHAPEL. The crematory, designed by A. J. Warner, was added in 1912. (Courtesy Richard O. Reisem.)

113

INDIAN TRAIL. During the Ice Age, the region was covered with ice one to two miles thick. As the glaciers retreated, cracks appeared in the ice and left riverbeds that, after the ice melted, formed ridges. One of these ridges snakes its way from the Bristol Hills to Lake Ontario. Once a Seneca trail, it is now a road in the cemetery called Indian Trail. (Courtesy Richard O. Reisem.)

FIRST SETTLERS. One of the first residents in primitive Brighton was Nancy Harris Quackenbush (1818–1900). She was born in a cabin that her grandfather Jacob Miller built in 1810 in dense woods. They had to barricade the door at night to keep out bears, wolves, and wildcats. After her death, Nancy was buried on the site of that cabin. (Courtesy Robert P. Meadows.)

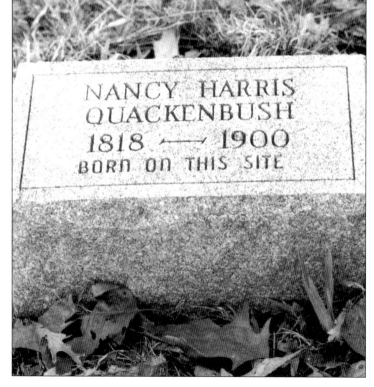

NANCY HARRIS QUACKENBUSH 1818 — 1900 BORN ON THIS SITE

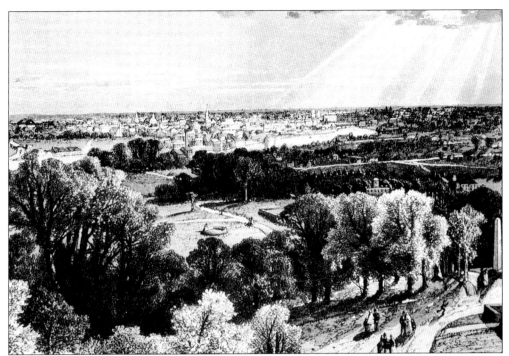

CITY AT PEACE, C. 1840. The city is bathed in sunshine in this view from Mount Hope Cemetery. (Courtesy Rochester City Photo Lab.)

GIFT TREES. In honor of Mount Hope Cemetery's 10th anniversary in 1848, nurserymen George Ellwanger and Patrick Barry donated 50 shade trees. Some of the original trees can be admired on tours of the cemetery Sunday afternoons at two and three from May to October. (Courtesy Robert P. Meadows.)

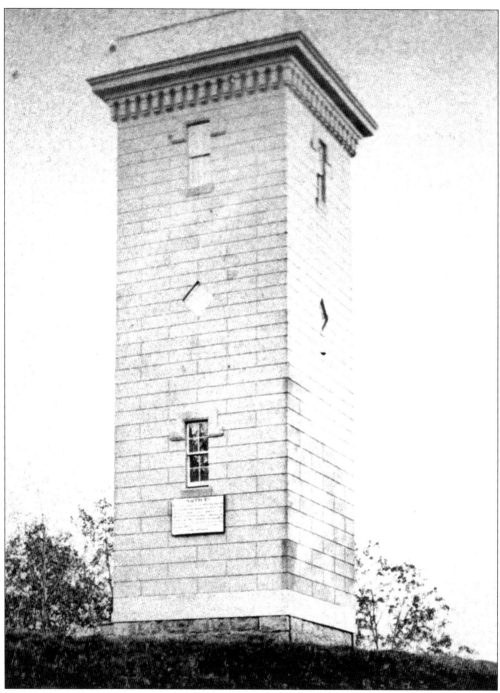

THE FANDANGO. Visitors climbed the stairs of this observatory on the summit of the hill at Mount Hope to view the Bristol Mountains to the south and the city, the river, and Lake Ontario to the north. On April 16, 1871, word spread of a spectacular, clear view of the Canadian shore, written up in a newspaper as "the Rochester Mirage." Thousands came to see the vista of Canadian landmarks, lakes and forest. (Courtesy Richard O. Reisem, photograph by Robert P. Fordyce.)

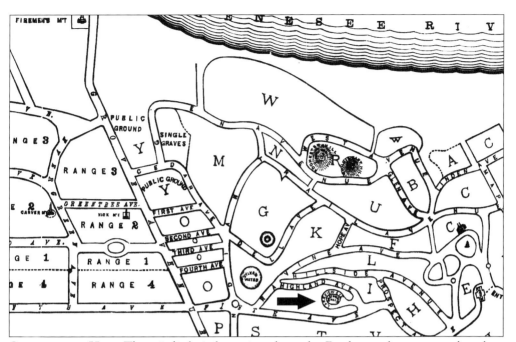

OBSERVATORY HILL. There is little information about the Fandango observatory other than a Ramsdell map of 1885, which shows its location within the cemetery by Highland Avenue. (Courtesy Rochester Public Library.)

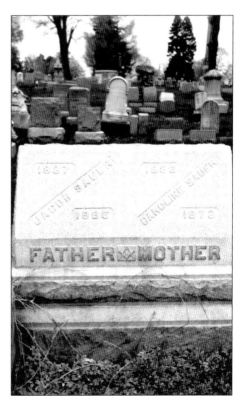

THE SAUER FAMILY. Jacob Sauer (1837–1885) was recorded as living at 53 Gregory Street in 1857 and then other addresses in the South Avenue area. There were 29 Sauers listed in the 1902 directory. Henry G. Sauer (1845–1935) was listed as a carpenter at 16 Gregory Street in 1887 and at 42 Gregory Street in 1902. He was a carpenter and boatbuilder for 40 years as well director and vice president at Columbia Banking, Savings and Loan Association, which had a branch listed at 337 Gregory Street in the 1928 directory. (Author's collection.)

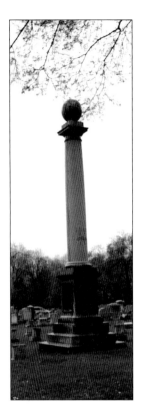

PEACE DOVE. The tall monument to John W. Stebbins (1819–1905) has a peace dove on one side of the base and the following inscription on the front: "55 years service in Odd Fellowship; erected by the lodges and encampments of New York State in Friendship, Love and Truth, 1908." It has been difficult to determine whether Stebbins Street in the South Wedge is named only for this accomplished baseball player, umpire, attorney, and Odd Fellows grand master. J. W. Stebbins organized the Rochester Mutual Health Association to supply cooperative health insurance in the city in the 1850s. (Author's collection.)

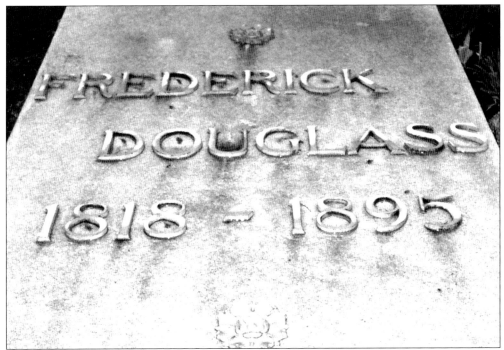

CEMETERY NOTABLES. Two of the most famous grave sites in Mount Hope Cemetery are for Frederick Douglass and Susan B. Anthony. They were good friends and argued publicly over who needed the vote most, women or black men. Another famous site is the grave of Lewis Henry Morgan, considered the father of American anthropology. He wrote Seneca Ely Samuel Parker's account of the Iroquoian way of life in *League of the Ho-de-no-saunee*, in 1851, and was a Corn Hill neighbor who died in 1881. (Courtesy Robert P. Meadows.)

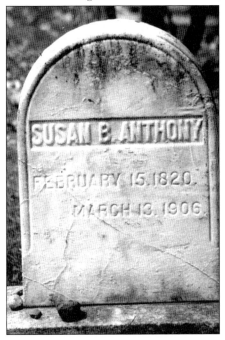
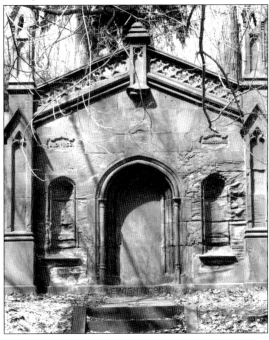

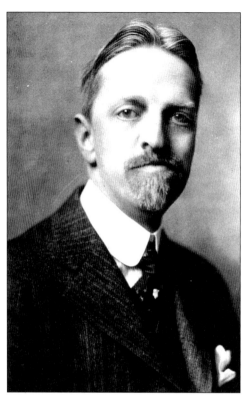

PIONEER CITY PLANNER. Charles Mulford Robinson (1869–1917) moved to Rochester as a boy and graduated from the University of Rochester in 1899. The plaque at the corner of Robinson Drive and Mount Hope Avenue reads, "Named in honor of Charles Mulford Robinson. Pioneer City Planner, Loyal Citizen, Christian Gentleman. He inspired the city to acquire this park and he planned the drive." Robinson's sister Jane was married to Henry H. Stebbins Jr. (1881–1952), the son of a well-known pastor at Central Presbyterian Church. William H. Stebbins is listed in the 1888 city directory as living at 18 Jefferson Street—a South Wedge street renamed Stebbins by 1900. (Left courtesy Rochester Public Library; below author's collection.)

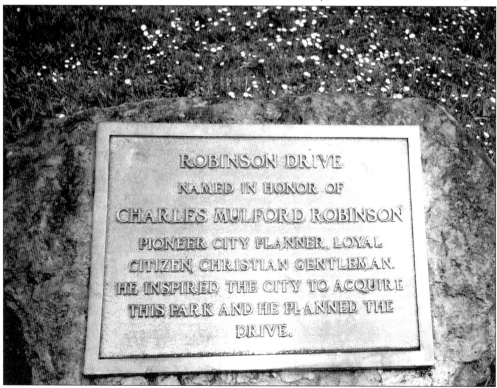

FREDERICK DOUGLASS STATUE. This statue of Frederick Douglass, the first public monument to an African American in the country, was moved from downtown to its present location in Highland Park Bowl and rededicated in 1941. Frederick Douglass published the first issue of the *North Star* on December 3, 1847, in Rochester. The paper's motto was "Right is of no sex. Truth is of no color. God is the Father of us all and we are all Brethren." Although the family moved to Washington, D.C., in 1872, Douglass chose to be buried in Rochester (where they had lived from 1847 to 1872) because he considered it home. (Courtesy Robert P. Meadows.)

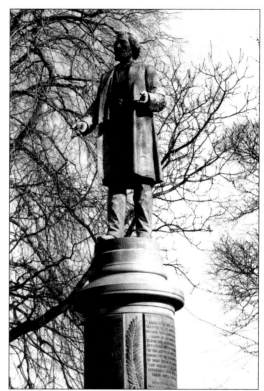

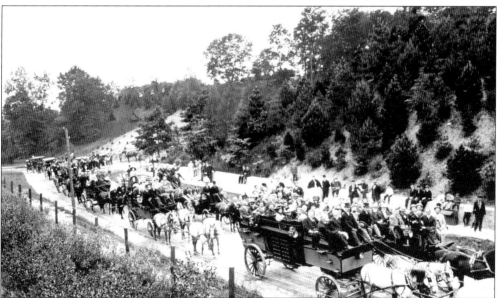

PROCESSION, 1905. The core of Highland Park began with a gift of 20 acres to the city in 1887 from nurserymen George Ellwanger and Patrick Barry. They had offered it in 1883. The park was designed by Frederick Law Olmsted. In 1891, horticulturist John Dunbar planted over 100 varieties of lilac bushes there. The first lilac festival was celebrated in May 1905 in the park's 22-acre lilac display area. The park superintendents had a grand procession in 1905. (Courtesy Rochester City Photo Lab.)

121

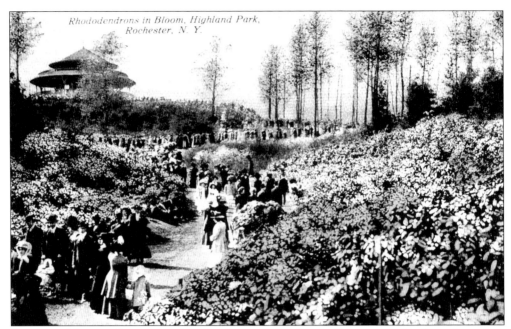

PARADISE VALLEY. During any decade, the rhododendron valley is a touch of paradise when it is in bloom. This *c.* 1910 view includes the Children's Pavilion. (Courtesy Rochester City Photo Lab.)

IRIS PARTY. In honor of Mount Hope Nursery's home in the South Wedge and Lincoln First Bank Highland Branch's 20th anniversary, the bank commissioned a Robert Conge six-color print from an original watercolor painting entitled *Highland Park Iris*. Proceeds were marked for the South Wedge Historical Office, which shared space with the South Wedge Tool Library in a storefront at 697 South Avenue in 1983. Rev. Judy Lee Hay, first South Wedge Planning Committee executive director, and Ron Meier, first board chair, enjoyed the event at the Garden Center in Warner Castle. The flier for the occasion noted that in addition to their legacy as nurserymen, George Ellwanger and Patrick Barry also founded the Flour City Bank, a forerunner of Lincoln First Bank N.A. (Courtesy South Wedge Planning Committee files.)

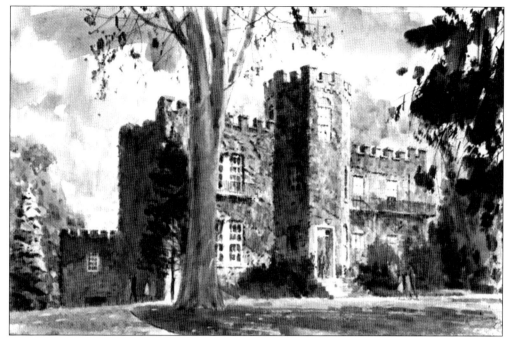

WARNER CASTLE. This postcard of a painting by Ralph Avery casts a soft light on the castle built in 1854 by antiabolitionist Horatio G. Warner. (Courtesy Josh Canfield.)

LOCAL HISTORIAN. Fourth-generation South Wedge native David "Josh" Canfield was honored for his efforts to promote neighborhood history. After his mother's death, he acquired all her old postcards and began collecting others. (Courtesy South Wedge Planning Committee files.)

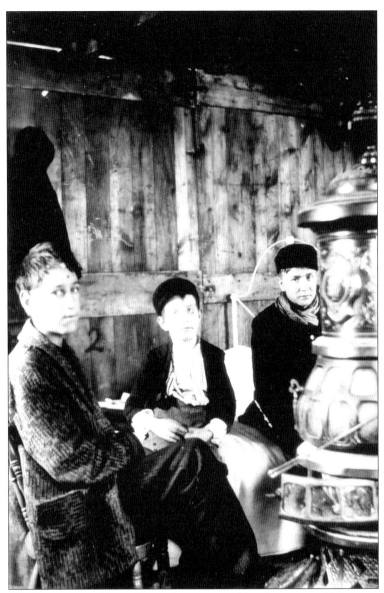

SMALLPOX PATIENTS, 1902. Hope Hospital was opened by the city in 1869 as a pest house, a much needed shelter for contagious diseases. It was built on the river flats in back of Mount Hope Cemetery and maintained for three decades. The late author Henry Clune, who grew up on Linden Street, described it around 1900 as a converted farmhouse on the east bank of the Genesee, close to stagnant Erie Canal waters and by a railroad bridge. It was a one-room, two-ward, 16-bed hospital with one water tap in the kitchen and no sewer. It had a double-partitioned outdoor privy labeled Ladies and Gents. The hospital used a weathered, unpainted shack for isolation cases and an old grocery wagon for an ambulance, which was pulled by a rented horse. Dr. George Goler protested conditions at Hope Hospital and warned of a smallpox epidemic, which began in February 1902. More than 100 out of the 1,000 people who got the disease died. The hospital was only equipped for 18 patients, but there were 143 smallpox cases in early December 1902 who were put up in tents. The hospital was burned down in 1903. (Courtesy Rochester City Photo Lab.)

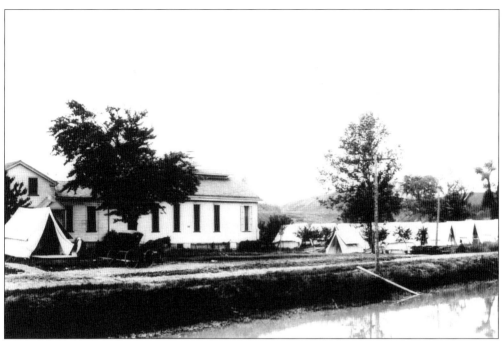

PATIENT TENTS. Shown are some of the tents used to accommodate smallpox patients in December 1902. (Courtesy Rochester City Photo Lab.)

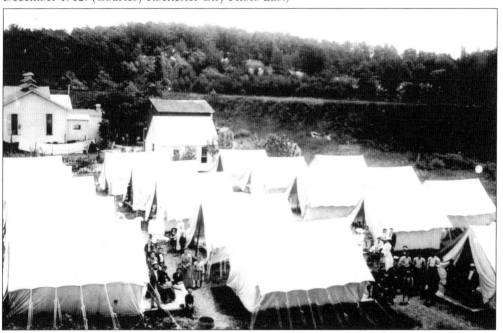

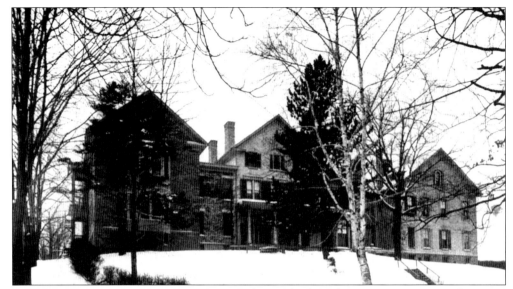

HAHNEMANN HOSPITAL. Disagreement in the medical profession was so strong that even before Hahnemann Hospital opened, a small group of staunch followers of Dr. Hahnemann had split and formed a separate society. Under the leadership of Dr. Joseph Biegler, Hahnemann Homeopathic Hospital opened on Oakland Street (Rockingham) in 1889. It was in the former home of Judge Henry Selden in what were called the Pinnacle Highlands. The hospital started out with 13 beds and increased to 40 within a decade. It became Highland Hospital in 1921. (Courtesy Rochester Public Library.)

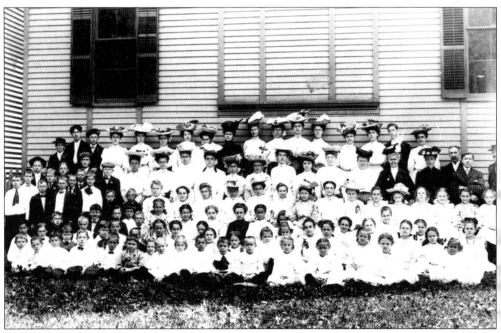

PEACE CHURCH. This photograph dates from 1890.

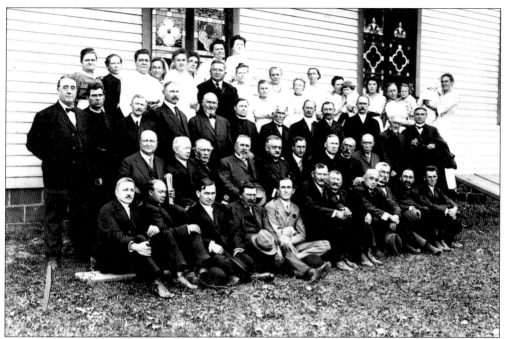

PEACE CHURCH. Lutheran Church of Peace, in the Ellwanger and Barry neighborhood, was founded in 1890 at the corner of Mount Vernon and Caroline Streets. The 1890 photograph shows the original building with shuttered windows. The back side is stamped, "Rochester Photo Company, 21 Bly Street." Sometime before 1928, the church added gorgeous stained-glass windows. Between 1930 and 1940, the church was resided in brick. (Courtesy Lutheran Church of Peace.)

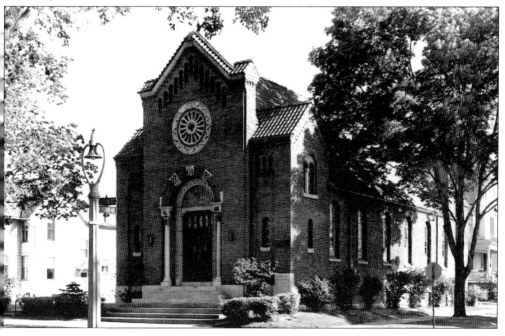

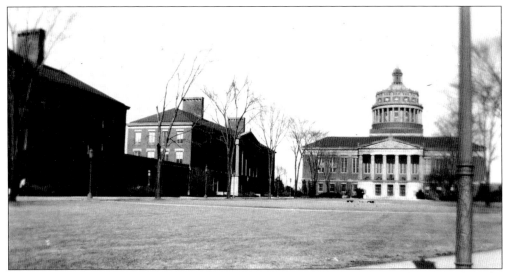

RUSH RHEES LIBRARY. South of Mount Hope Cemetery along the winding river lies the University of Rochester campus, seen here in the early 1950s. The University of Rochester was first founded in 1850, along with the Rochester Theological Seminary, by a group of Baptists. It was located in the United States Hotel on West Main Street. Largely due to the efforts of women's rights advocate Susan B. Anthony, women were admitted to the college in 1890. During Rush Rhees's presidency, from 1900 to 1935, George Eastman became a major donor, and the Eastman School of Music and the School of Medicine and Dentistry were founded. (Courtesy Candy Harris.)

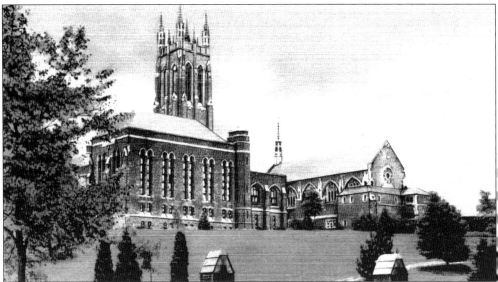

COLGATE ROCHESTER. The Colgate Divinity School was founded in 1817 in Hamilton, New York. It merged with the Rochester Theological Seminary in 1928 at a new campus on the hill at 1100 South Goodman Street. Helen C. Ellwanger, who was the granddaughter of nurseryman George Ellwanger, once described a vineyard full of rare European grapes that covered the land where Colgate Rochester Divinity School was later built. She founded the Landmark Society and, upon her death at age 96 in 1982, her house at 625 Mount Hope Avenue was donated to the society. (Courtesy Rochester Public Library; information from the *Times-Union*, May 3, 1982.)